AMERICAN WEST

Bill O'Neal

Publications International, Ltd.

Bill O'Neal is the author of *Best of the West* and *Ghost Towns of the American West* and a contributor to *Legends of the Wild West* and *Chronicle of the American West*. Other titles by O'Neal include *Cheyenne, 1867–1903: A Biography of the Magic City of the West* and *The Sons of the Pioneers*. His book *The Johnson County War* was named 2005 Book of the Year by the National Association for Outlaw and Lawman History. He is a member of the Western Writers of America, Inc., a past president of the East Texas Historical Association, and a board member of the National Association for Outlaw and Lawman History.

Factual verification by **Marci McGrath** and **Chris Smith.**

Copyright © 2006, 2021 Publications International, Ltd. All rights reserved. This book may not be reproduced or quoted in whole or in part by any means whatsoever without written permission from:

Louis Weber, CEO
Publications International, Ltd.
8140 Lehigh Avenue
Morton Grove, IL 60053

Permission is never granted for commercial purposes.

ISBN: 978-1-64030-722-3

Manufactured in China.

8 7 6 5 4 3 2 1

Let's get social!
@Publications_International
@PublicationsInternational
www.pilbooks.com

CONTENTS

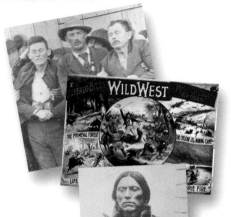

CHAPTER ONE
Rebels and Outlaws

The vast spaces and rugged terrain of America's West beckoned renegades and outlaws. But fast-shooting officers, unafraid of violent confrontations, rode in hot pursuit.

"We are rough men and used to rough ways."
—*Bob Younger*

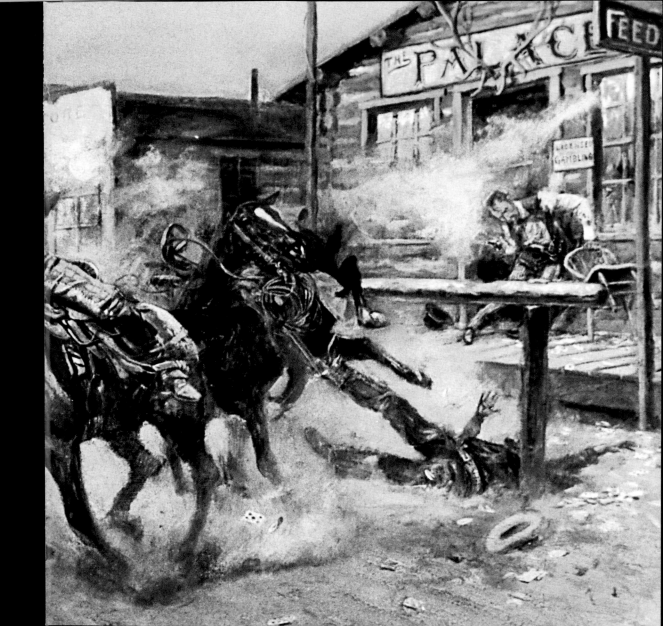

BILLY THE KID

1859—1881

At just 17 years old, Billy the Kid became embroiled in a saloon brawl in 1877 near Camp Grant, Arizona Territory. Billy was wrestled to the floor by a burly blacksmith, F. P. Cahill. But the slender teenager pulled a revolver and fatally wounded Cahill. A known horse rustler, the Kid already had engineered a jail escape, and now he fled to lawless Lincoln County, New Mexico, ahead of a murder charge.

Billy the Kid was employed shortly thereafter on the Lincoln County ranch of Briton John Tunstall. But Tunstall was murdered in 1878, almost before Billy's eyes, triggering the bloody Lincoln County War. Swearing vengeance, the Kid joined a band of "Regulators" that assassinated two members of the opposing faction. Billy then led an ambush that resulted in the deaths of Lincoln County's sheriff and chief deputy.

There was other gunplay, including the five-day Battle of Lincoln in July 1878. Billy the Kid formed a band of stock thieves, and in 1880 he killed a gunfighter named Joe Grant in a Fort Sumner saloon. But the new Lincoln

County sheriff, Pat Garrett, relentlessly pursued the Kid and his gang. Two of Billy's closest confederates, Tom O'Folliard and Charlie Bowdrie, were killed in separate encounters with Garrett and his posse. Finally cornered, the Kid killed two guards and escaped to the countryside. But Garrett soon surprised his prey in a dark room 25 miles from Fort Sumner, triggering a bullet into Billy's heart. Billy the Kid was buried between O'Folliard and Bowdrie, and engraved at the top of the common marker for the outlaw trio was the word "PALS".

By the time he was killed, the Kid fought in at least 16 shoot-outs. He killed four people and helped to kill five others. The young outlaw, whose real name was Henry McCarty, had a string of aliases—William H. Bonney, William Antrim, Kid Antrim, and Billy the Kid. After his death, legend proclaimed that Billy the Kid had killed 21 people, one for each year of his life.

"I, at no time, contemplated **taking any chances** [with Billy the Kid] which I could **avoid by caution or cunning.** The only circumstances under which we could have met on **equal terms**, would have been **accidental,** and to which I would have been an **unwilling party.**"

Pat Garrett

REWARD
($5,000.00)

Reward for the capture, dead or alive, of one Wm. Wright, better known as

"BILLY THE KID"

Age, 18. Height, 5 feet, 3 inches. Weight, 125 lbs. Light hair, blue eyes and even features. He is the leader of the worst band of desperadoes the Territory has ever had to deal with. The above reward will be paid for his capture or positive proof of his death.

JIM DALTON, Sheriff.

DEAD OR ALIVE!
"BILLY THE KID"

—*Lincoln County Sheriff Pat Garrett*

Be not afraid of any man,
No matter what his size;
When danger threatens call on me,
And I will equalize.

—One version of a commonly quoted nineteenth-century saying about the Colt .45 Equalizer

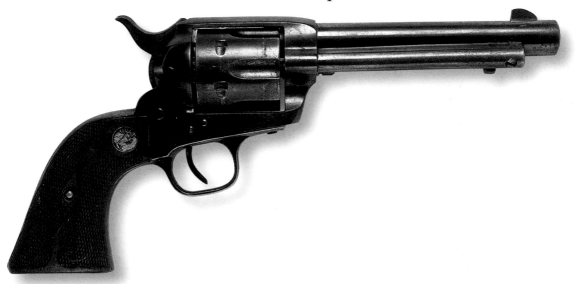

Starring, Billy the Kid!

Billy the Kid has been portrayed in more than 40 films, more than any other Western figure to date. He was first played on-screen by Johnny Mack Brown in *Billy the Kid* (1930). The brilliant young star ◀**Paul Newman** was the Kid in ***The Left-Handed Gun*** (1958), and Kris Kristofferson played Billy in *Pat Garrett and Billy the Kid* (1973).

Other actors who have played the infamous outlaw include Robert Taylor, Roy Rogers, Audie Murphy, Don "Red" Barry, Scott Brady, Nick Adams, and **Emilio Estevez** ▼ in *Young Guns* (1988) and *Young Guns II* (1990).

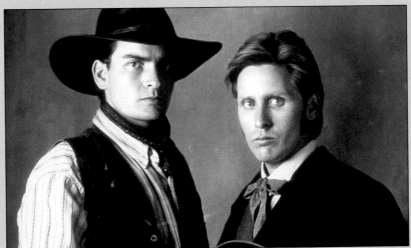

Brothers Charlie Sheen (left) and Emilio Estevez starred in Young Guns together.

BELLE STARR

1848–1889

"It seems as if I have more trouble than any person," lamented Belle Starr. But she brought on most of the trouble herself.

Born Myra Maybelle Shirley in Carthage, Missouri, she was educated in a school for girls and became a fine pianist. Belle also was an accomplished horse rider, and her brother Bud, a Confederate guerrilla, taught her how to handle firearms.

Her taste for desperadoes linked her romantically with thieves and killers. After her family moved to Texas, she married Jim Reed, a bank and train robber and murderer who was slain by a member of his own gang in 1874. Her second husband was horse thief Sam Starr. Her other lovers were equally unsavory.

Belle tended sick neighbors and sought gentility for herself and her daughter Pearl. But she often flogged her adolescent son, Eddie, with a riding whip, and the Starrs's wilderness cabin in Oklahoma became a hide-out for fugitives. Sam and Belle were sent to prison for five months for horse theft, and in 1886 Sam was killed in a gunfight.

Three years later Belle, now known as the "Bandit Queen," was blasted off her horse with a shotgun. Her assassin was never apprehended.

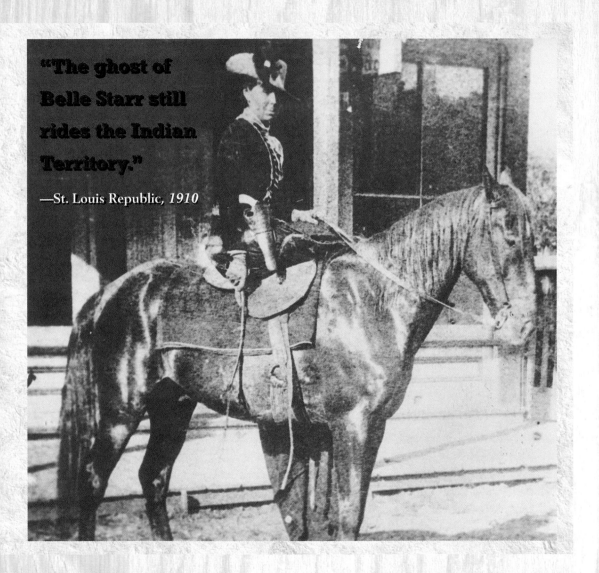

"The ghost of Belle Starr still rides the Indian Territory."

—St. Louis Republic, *1910*

Time's Up!

A highly polished pocket watch placed on the table could be used to read the face cards as the gambler dealt. Such "advantage tools" could be ordered from a catalog.

"I'VE **NEVER** SEEN ANYONE GROW **HUMPBACKED** CARRYING AWAY THE MONEY THEY WON FROM **ME.**"

—*Poker Alice Ivers, frontier gambler*

LUKE SHORT

1854–1893

No gambler was more dangerous than Luke Short. The dapper Short carried his revolver in a tailored pants pocket lined with leather, using the weapon to drill several adversaries in saloon fights in Dodge City, Tombstone, Leadville, and Fort Worth.

Friend and fellow gambler Bat Masterson was present during Short's two most famous shoot-outs. The two men were house dealers at Tombstone's Oriental Saloon in February 1881. It was here that, after quarreling over a card game, Short and gambler Charlie Storms angrily went for their guns. One slug from Short broke Storms's neck, and a second tore into his heart.

In 1887 Short owned one-third interest in Fort Worth's infamous White Elephant Saloon. He resisted a shakedown by former city marshal Jim Courtright. Confronting Short and the nearby Masterson, Courtright pulled a six-gun, but the hammer caught on his watch chain, and Short whipped out his own revolver. Short's first slug disabled Courtright's pistol, and other bullets struck Courtright's thumb, shoulder, and heart.

Short died six years later at age 39 of dropsy (excessive fluid accumulation) and was buried near Courtright in Fort Worth.

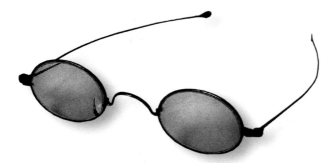

Blue-tinted glasses could be used to read the backs of cards marked with phosphorescent ink invisible to the naked eye.

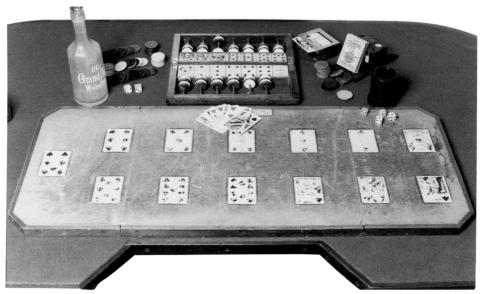

The spread of this faro layout has each of the 13 cards of every rank, and players would bet by placing chips on certain cards. The "casekeeper" (at the top of the picture) was a device used by the dealer to indicate which cards had been played.

Gamblers' Advantage

The dice are loaded and the cards are marked, although the chips are honest. Gamblers often filed their fingertips for greater sensitivity while handling marked cards.

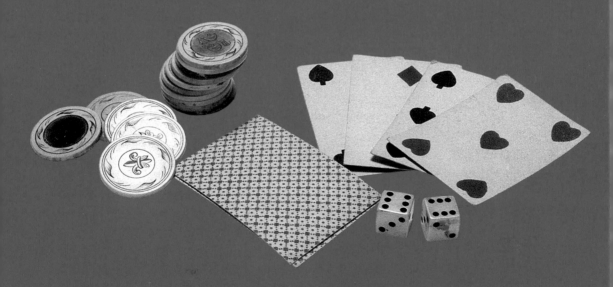

"I am conducting a fair, legitimate business. My mission is to skin suckers."

—Charles "Doc" Baggs, *frontier gambler*

JOHN WESLEY "WES" HARDIN

1853—1895

The West never produced a more prolific killer than John Wesley Hardin, a Texas preacher's son named after the founder of Methodism. As a youthful hunter Hardin became an expert shooter, and he ceaselessly practiced twirling and tossing revolvers. During future incarcerations, guards would provide unloaded pistols so they could enjoy his astounding demonstrations of gun handling.

Hardin killed his first person at 15, pumping three slugs into the chest of a former slave. Now wanted for murder by Reconstruction officials, Hardin went on the run, repeatedly defending himself with deadly aggressiveness.

The young killer freely indulged in liquor, card playing, and horse racing, activities that invited violence in the Old West. From 1868 through 1874, Hardin was involved in one shoot-out after another, usually triggering the first shot himself. Seeking refuge with relatives in South Texas, Hardin joined a band of accomplices in waging the bloody Sutton-Taylor feud.

Hardin celebrated his 21st birthday in 1874 by winning heavily at horse racing in Comanche, Texas. Afterward, he quarreled in a saloon with Deputy Sheriff Charles Webb, and the two men pulled their pistols and

fired. Hardin was struck in the side, but Webb took a bullet in the head. Webb jerked his trigger as he was hit, and two of Hardin's companions pumped slugs into the officer as he went down. An enraged mob chased Hardin and his party out of town. Hardin's brother and two others were lynched in Comanche while Hardin escaped to Florida with a $4,000 reward on his head. He brought his young wife and daughter to Florida, where another daughter and son were soon born.

Hardin is shown in 1872.

In 1877 Hardin was found and arrested by a Texas Ranger. He spent 15 years in a Texas penitentiary, making several attempted escapes before deciding to put his time to better use. He studied for the bar, penned an autobiography, and piously taught Sunday school in prison.

Although Hardin won release from prison in 1892, his wife recently had died. He practiced law in Junction, Texas, and married a young woman, who left him on the day of the wedding. Restlessly Hardin moved his law office to El Paso, but he drank and caroused with a hard crowd. He clashed with Constable John Selman, who shot Hardin in the back on August 19, 1895.

Best Cattle Town Saloons

The best cattle town saloons provided liquor, food, baths, barbers, music, spittoons, gambling layouts, hand-carved bars with brass railings and mirrors.

Alamo, Abilene, Kansas

Bull's Head, Abilene, Kansas

Long Branch, Dodge City, Kansas

Reno House, Wichita, Kansas

Cowboy's Rest, Ogallala, Nebraska

Red Light, Caldwell, Texas

White Elephant, Fort Worth, Texas

Buckhorn, San Antonio, Texas

Equity Bar, Tascosa, Texas

Gold Room, Cheyenne, Wyoming

Best Nicknames for Liquor

Coffin Varnish

Gut Warmer

Lamp Oil

Pop Skull

Scorpion Bible

Stagger Soup

Tanglefoot

Tarantula Juice

Tonsil Paint

Wild Mare's Milk

*Julia Bulette was a madam and working woman in the Nevada boom town of
Virginia City, the location of the first vein of silver ore found in the U.S. Known as
having a heart of gold, Bulette was a beloved figure in Virginia City among
miners and firefighters—so much so that she was made an honorary firefighter of
the Virginia Engine Company Number 1. Her successful, independent operation
put her in direct competition with many of the larger and fancier saloons in
the city. She was killed in January 1867 by a jewel thief named John Millain.
Millain was quickly hanged to death while the town honored Bulette with a
luxurious funeral.*

Ladylike Nicknames

Squirrel Tooth Alice
Working women were among the earliest entrepreneurs to descend upon the West. Their brothels could be stately mansions, one-room "cribs," or even tents. These red-light ladies often earned a very nice income.

Big Matilda

Box Car Jane

Cotton Tail

Crazy Horse Lil

Frog Lip Sadie

Gizzard Lip

Homely Ann

Midnight Rose

Mustang Mae

Squirrel Tooth Alice

Gunfight at the O.K. Corral

Life and death are the stuff of high drama, and on October 26, 1881, Tombstone's O.K. Corral provided the West with one of its most memorable scenes. The cast of characters included three clannish sets of brothers—the Earps, the Clantons, and the McLaurys—and the doomed, alcoholic dentist Doc Holliday. The Earp brothers often found employment in law enforcement, while the Clantons and McLaurys were ranchers who engaged in rustling and possibly other types of outlawry.

Following confrontations with the Earps and Holliday, Ike and Billy Clanton and Tom and Frank McLaury, along with Billy Claiborne, gathered at a vacant lot near the O.K. Corral. Suddenly they were approached by Tombstone's town marshal, Virgil Earp, "deputies" Wyatt and Morgan Earp, and Holliday.

"You sons of bitches," growled Wyatt, "you've been looking for a fight and now you can have it!"

"Throw up your hands!" ordered Virgil.

Morgan brought up his revolver and shot 19-year-old Billy Clanton in the chest. Sprawling onto his back, Billy began firing at his opponents.

Wyatt shot Frank McLaury in the stomach. Clutching his middle with his left hand, Frank fired back with a revolver in his right hand. Holliday triggered a shotgun blast at Tom McLaury, who collapsed with a 12 buckshot under his right arm.

Ike Clanton and Claiborne fled the scene, while the wounded Billy Clanton and Frank McLaury desperately fought back. Virgil was hit in the leg and Morgan in the shoulder, while Doc was grazed in the side. But young Clanton was put out of action with another slug in the abdomen, and Morgan fired a bullet into Frank's head.

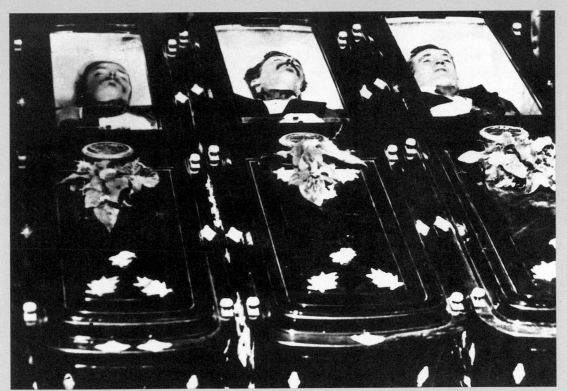

R.I.P. (left to right) Tom McLaury, Frank McLaury, and Billy Clanton on their way to Tombstone's Boot Hill after fighting at the O.K. Corral.

"I got him!" exulted Morgan.

The McLaury brothers were dead on the spot, and Billy Clanton died in agony a few minutes later. Within the next few months, Virgil was severely wounded and Morgan was killed in separate ambushes, prompting Wyatt and Holliday to lead a murderous vendetta.

Tombstone's Most Famous Boot Hill Epitaph:

HERE LIES

LesterMoore
FOUR SLUGS
FROM A 44
NO LES
NO MORE

"Me, I want to get killed in ONE HELL-FIRIN' MINUTE of smoking action."

—Black-Faced Charley Bryant

The Oklahoma outlaw was nicknamed Black-Faced because of powder burns from a point-blank pistol blast. On August 23, 1891, Bryant and Deputy U.S. Marshal Ed Short killed each other in one hell-firin' minute of action on a train near Wichita, Kansas.

Derringers

More than 150,000 of these .41-caliber Remington Over and Under hideout guns were sold. Most professional gamblers packed some type of derringer as well as a knife.

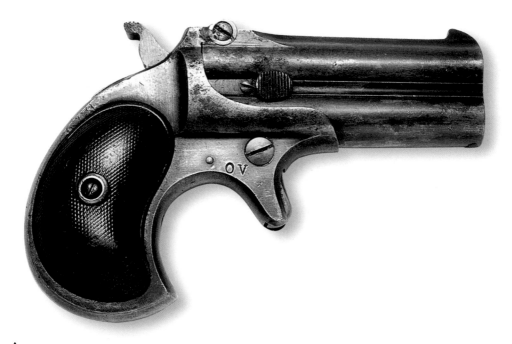

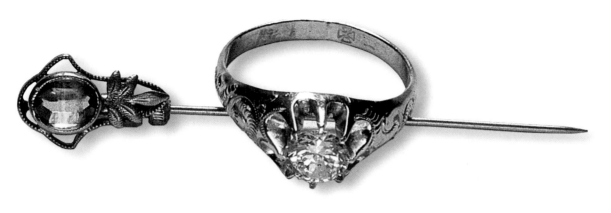

LOW ON DOUGH?

GAMBLERS SPORTED DIAMOND RINGS AND JEWELED
STICKPINS AS WELL AS GOLD WATCHES, CHAINS, AND RINGS.
SUCH BAUBLES COULD BE WAGERED WHEN A GAMBLER
RAN LOW ON CASH.

Best Gunfighter Nicknames

Curly Bill Brocius (William Graham)

Cherokee Bill (Crawford Goldsby)

Wild Bill (James Butler) Hickok ▸

Broken Nose Jack McCall

Billy the Kid (Henry McCarty)

Cockeyed Frank Loving

The Human Wildcat (Juan Soto)

Dingus (Jesse James)

The Sundance Kid (Harry Longbaugh)

Killin' Jim Miller

HE WAS WRONG. DEAD WRONG.

"I don't believe the **bullet** was ever made that will **kill** me."

—*Dallas Stoudenmire, El Paso city marshal, killed in 1882 by James and Doc Manning*

Killin' Jim Miller

1866–1909

The West's premier assassin was called **"Killin' Jim"** and **"Killer Miller"**—
but **never** to his face.

❧ ❧ ❧

At the age of **eight** the Texas boy murdered his grandparents,
and at **17** he shot his brother-in-law in the head.

❧ ❧ ❧

At various times Killin' Jim wore a **badge** as a deputy sheriff,
town marshal of Pecos, and Texas Ranger.

❧ ❧ ❧

Sheriff Bud Frazer shot Miller in 1894. But Miller wore a steel breastplate,
and two years later he **blasted** Frazer with a shotgun.

❧ ❧ ❧

Paid $500 to assassinate Lubbock lawyer James Jarrott,
Miller had to shoot his victim **four times**.
"He was the hardest damn man to kill I ever tackled."

Sometimes called "Deacon Jim," Jim Miller was regularly seen attending service at a Methodist church and was known for not drinking or smoking. But, aside from his prudence in such practices, he was still a very dangerous outlaw who is thought to have killed at least 12 people in gunfights throughout his life.

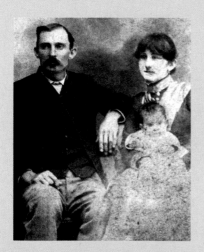

Miller and his family in the 1890s. Miller was lynched in 1909 in Ada, Oklahoma, by an angry mob, who brought Miller and his three associates to justice for the killing of a former deputy U.S. marshal, A.A. Bobbitt.

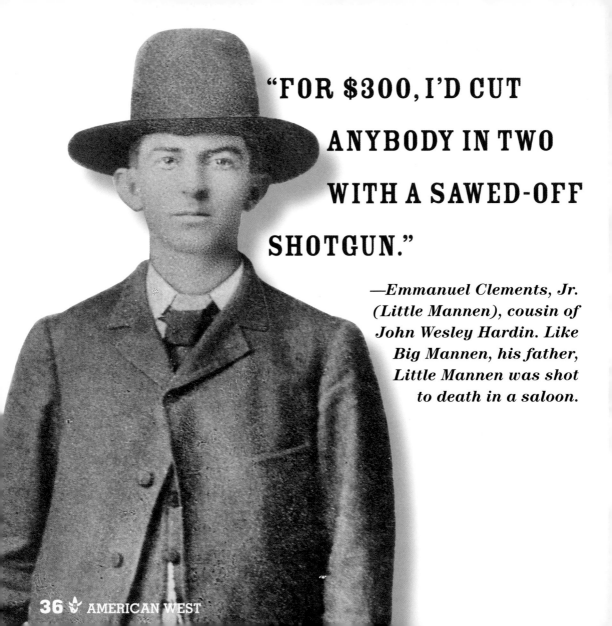

"FOR $300, I'D CUT ANYBODY IN TWO WITH A SAWED-OFF SHOTGUN."

—*Emmanuel Clements, Jr. (Little Mannen), cousin of John Wesley Hardin. Like Big Mannen, his father, Little Mannen was shot to death in a saloon.*

"A gun is just a tool. No better and no worse than any other tool. A gun is as good—and as bad—as the man who carries it."

—Shane, *by Jack Schaefer*

Frank and Jesse James

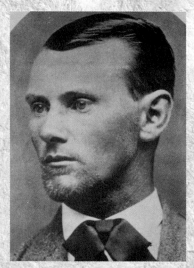

Jesse James

Frank (born 1843) and Jesse (1847) James were the sons of a Baptist preacher and a strong-willed mother. Born and raised on a slave-holding Missouri farm, the James brothers joined William Quantrill's infamous band of Confederate guerrillas during the Civil War. Teenaged Jesse was twice wounded, but he recovered to loot and kill until the end of the war.

During the decade after the war Jesse—a natural leader—and Frank, along with the Younger brothers and other thieves, allied to rob banks, stores, stagecoaches, and trains. In 1866 the James-Younger Gang pulled off America's first daylight bank robbery during peacetime, plundering $60,000 from the Clay Savings Bank in Liberty, Missouri.

Shooting often broke out during the gang's holdups. But following each robbery that he was blamed for, Jesse customarily published a letter proclaiming his innocence and establishing an alibi. Jesse was baptized in

1868 and, aside from numerous robberies and a few murders, remained a devout Christian throughout his life.

In 1876 the James-Younger Gang was shot to pieces during an abortive bank robbery in Northfield, Minnesota. Jesse and Frank escaped, then went into hiding under assumed names with their wives and children. By 1882 Jesse was forming a new gang, but a recruit, Bob Ford, murdered him for reward money.

Jesse was buried in the front yard of his mother's farm, and she charged tourists 25 cents apiece to view the grave. She wept melodramatically at the persecution of her sons and wished damnation upon Ford. She also sold pebbles from Jesse's grave for 25 cents each and regularly replenished her supply from a nearby creek.

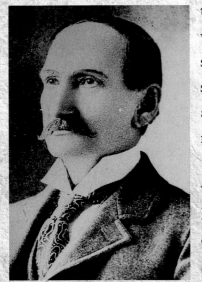

Frank James

Frank outlived his younger brother by more than three decades. Soon after Jesse's death, Frank surrendered to authorities and then engaged in legal maneuvers that led to his acquittal in 1883. He led a quiet, honest existence, dying on the family farm in 1915.

"I have been **hunted** for 21 years. I have literally **lived** in the saddle. I have **never** known a day of **perfect peace**.... When I slept, it was literally in the midst of an **arsenal**. If I heard **dogs bark** more **fiercely** than usual, or the **feet of horses** in a greater volume than usual, I **stood to arms**. Have you **any** idea what a man must **endure** who leads such a life? **No, you cannot.**"

—*Frank James,*
upon his surrender

Blood Brothers

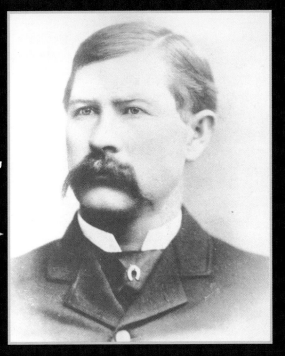

CLANTON, Billy and Ike

DALTON, Bill, Bob, Emmett, and Grat

EARP, Morgan, Virgil, Warren, and Wyatt

HORRELL, Ben, Mart, Merritt, Sam, and Tom

JAMES, Frank and Jesse

McLAURY, Frank and Tom

LOGAN, Harvey and Lonie

THOMPSON, Ben and Billy

MASTERSON, Bat, Ed, and Jim

YOUNGER, Bob, Cole, Jim, and John

The Younger Brothers

There were 14 Youngers, the children of a Missouri politician and slave-holder who farmed near Lee's Summit. The murder of their father during the Civil War embittered four of the boys and propelled them to outlawry.

Soon after his father's murder, Cole Younger (the seventh child, born in 1844) killed one of the people responsible. Cole rode with regular Confederate troops and with the guerrilla raiders of William Quantrill. During a skirmish, Cole killed his first person with a pistol shot measured at 71 yards.

Stationed in Texas in 1863, Cole met a tempestuous 16-year-old, Myra Maybelle Shirley, who later became famous as Belle Starr. She would claim that her daughter Pearl was sired by Younger.

After the war Cole, along with brothers John (born in 1846), Jim (1850), and Bob (1853), joined Jesse and Frank James to form a bandit gang that ran rampant for years. Although Jesse was the acknowledged leader of the James-Younger Gang, Cole never got along well with Jesse and led several robberies himself.

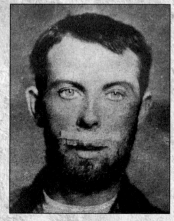

Jim Younger

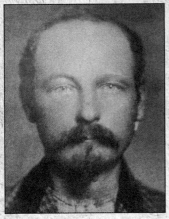

Cole Younger

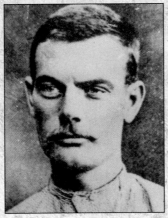

Bob Younger

In 1874 John Younger was killed during a bloody shoot-out with officials. Two years later the James-Younger Gang met fierce resistance during a bank robbery in Northfield, Minnesota. Two of the outlaws were killed and most of the others were wounded in the streets of Northfield. A two-week search ensued, and only Frank and Jesse managed to escape. A pursuit posse killed a third gang member then accepted the surrender of Cole, Jim, and Bob.

Cole had been shot 11 times, Jim had been hit with five bullets, and Bob had been shot twice. Amazingly, they all survived but were captured.

Bob died in prison of tuberculosis in 1889 at the age of 35. Jim and Cole were released from custody in 1901. But Jim was plagued with health and financial problems, and the next year he committed suicide.

Cole teamed up with Frank James in a Wild West Show venture, and later the reformed outlaw traveled widely, lecturing on his adventures and the evils of crime. Cole retired to Lee's Summit and died there in 1916 at 72.

Outlaws Beware

When Sam Clemens went west, he did not neglect to bring a firearm:

"I was armed to the teeth with a pitiful little Smith & Wesson's seven-shooter, which carried a ball like a homeopathic pill, and it took the whole seven to make a dose for an adult. But I thought it was grand. It appeared to me to be a dangerous weapon. It only had one fault—you could not hit anything with it."

—*Mark Twain*

A Good View

Charles Goodnight and his bride checked into the Drover's Hotel in Pueblo, Colorado, on the same night that **two outlaws** were lynched outside. The next morning, Molly Goodnight exclaimed that two men were hanging from a telegraph pole. "Well," stammered Charles, who had played a role in the summary justice, "I don't think it hurt the **telegraph pole.**"

Deadliest Bank Robberies

September 7, 1876: Northfield, Minnesota

When the James-Younger Gang tried to rob the First National Bank, two citizens and two outlaws were killed and others were wounded. During a two-week pursuit, another robber was killed and three Younger brothers, all wounded, were captured. Only Frank and Jesse James escaped.

April 30, 1884: Medicine Lodge, Kansas

Caldwell city marshal turned bank robber Henry Brown led his deputy and two other cohorts in a raid on the Medicine Valley Bank. After the bank president and clerk were killed at the bank, a posse promptly captured the robbers and lynched them that night.

October 5, 1892: Coffeyville, Kansas

Bob, Grat, and Emmett Dalton along with two accomplices tried to loot a pair of banks simultaneously. Four citizens were killed and three others

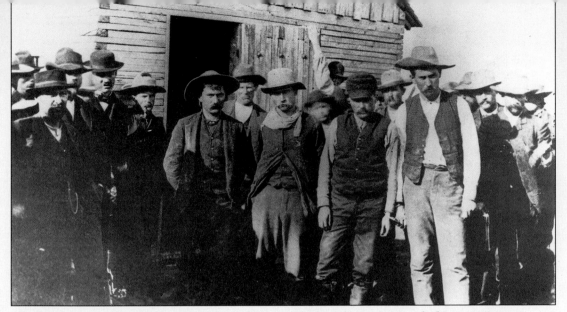

The Medicine Lodge bank robbers are shown with their captors. Marshal Henry Brown (center) is wearing a light hat and neckerchief.

wounded, but all five outlaws were gunned down. Only Emmett survived to go to prison.

May 23, 1894: Longview, Texas

Another Dalton brother, Bill, led three other outlaws to Longview's First National Bank. Shooting their way out of town, the gang killed two citizens and wounded three others. One robber was shot dead then hanged from a telegraph pole. Two weeks later Dalton was cornered by a posse and slain.

THE DALTON BROTHERS

The Dalton family was distantly related to the Youngers and claimed an even more distant kinship to the Jameses. Lewis and Adeline Dalton produced ten sons and five daughters, and four of the boys came to believe that outlawry was in their blood.

An older brother, Frank, was killed while serving as a deputy U.S. marshal under Judge Isaac Parker. But Grattan (born in 1861), Bob (1870), and Emmett (1871) decided to follow their "heritage" on the other side of the law.

The Dalton Gang would include Grat, Bob, and Emmett; Bill Doolin; Bitter Creek Newcomb; Dick Broadwell; Charley Pierce; Bill Powers; and Black-Faced Charley Bryant. Bob's sweetheart, Eugenia Moore, was the gang's advance agent until she died of cancer in 1892. During 1891 and 1892 the Dalton Gang pulled a series of train robberies and assorted holdups.

Soon the Daltons decided to seek outlaw immortality by robbing two banks simultaneously in Coffeyville, Kansas. Bob, Grat, and Emmett, accompanied by Broadwell and Powers, rode into Coffeyville on October 5, 1892. But the Daltons were recognized as they rode into town, and by the time the five outlaws emerged from the two banks with their loot, they faced an armed populace.

A dozen people were shot in the ensuing gun battle. Four of the gang members were killed, along with four townspeople. Emmett, blasted out of

the saddle with a shotgun, was the only outlaw to survive. After serving 14 years in prison, Emmett spent the last 30 years of his life crusading against crime and for prison reform.

Embittered that his brothers had been gunned down, Bill Dalton, (born in 1863) decided to strike back at society. Bill became second-in-command of the Okla-hombres, an outlaw gang led by Doolin. But when Dalton led a bloody bank robbery in Longview, Texas, on May 23, 1894, a posse tracked him two weeks later to a hideout in Oklahoma and killed him. Dalton's wife learned she was a widow when she saw Bill's bloated body being hauled into town by officials.

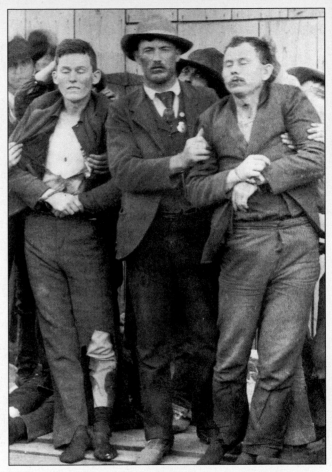

Bob (left) and Grat (right) are propped up after being slain by the citizens of Coffeyville.

EMMETT DALTON

1871–1937

After being pardoned from prison in 1907, Emmett Dalton worked successfully at honest enterprise and married his long-suffering sweetheart, Julia Johnson. In 1909 Dalton returned to Coffeyville, Kansas, to act as adviser on a short film about his infamous 1892 raid. Moving to Los Angeles in 1920, Dalton enjoyed a brief career as a technical adviser for Hollywood Westerns. He wrote movie scenarios and acted in a few bit parts.

Emmett also crusaded against crime by describing the violent deaths of his brothers Bob, Grat, and Bill. Pointing to his brothers as examples, he proclaimed that anyone who thought he could beat the law was "the biggest fool on earth."

He detailed his exploits as an outlaw in numerous lectures and writings, including *When the Daltons Rode*, published in 1931. In 1940, three years after Emmett's death, a Western film based on this book was released, starring Randolph Scott.

———◦———

"**What I had to offer Julia, a man with a price on his head and no clear way to extricate myself from the compounding results of crime? I rode away. An outlaw has no business having a girl, no business thinking of marriage.**"

CHARLES BOLES

1830–1917

One of the West's most legendary outlaws was a California stagecoach robber who sometimes left verses at holdup sites with the signature, "Black Bart, The Po-8."

Black Bart's real name was Charles E. Boles, and he was born in New York in 1830. Attracted to the West by the gold rush, Boles eventually decided that the only gold he

could find was inside Wells, Fargo & Co.'s Express strongboxes.

From 1875 to 1882 Boles staged almost 30 robberies. His loot totaled $18,000, and he never shot anyone or robbed a passenger.

Between robberies he resided at a San Francisco hotel, nattily dressed in a derby hat and business suit and sporting a diamond stickpin, a gold watch and chain, and a walking cane.

"Madam, I do not want your money. In that respect, I honor only the good office of Wells Fargo."

Finally discovered by detectives, Boles served four years in San Quentin, and then he disappeared. But his one-person campaign of banditry against the West's most prestigious express company assured him a special place in the rogues' gallery of America's outlaws.

Sam Bass Gang *vs.* Texas Rangers

In 1877 and 1878, Sam Bass led various desperadoes in robbing at least seven stagecoaches and five trains. Posses killed two of his associates, but Bass remained at large. In July 1878 he decided to rob a bank in Round Rock, 20 miles north of Austin, Texas.

Bass reached Round Rock with Seaborn Barnes, Frank Jackson, and Jim Murphy. But Murphy had betrayed Bass, informing Texas Rangers of the robbery plans in exchange for leniency. Murphy knew that Round Rock would be swarming with Rangers and other officials, so when the gang headed into town to case the bank, Murphy dropped back, muttering something about buying corn for the horses.

Bass, Barnes, and Jackson tied their horses in an alley and then went into a store adjacent to the bank to buy tobacco. There they were confronted by two deputy sheriffs who were suspicious of guns worn by the trio.

The three outlaws whipped out their revolvers and gunned down both officials. Bass, wounded in the hand, led a sprint for the horses as several Texas Rangers opened fire.

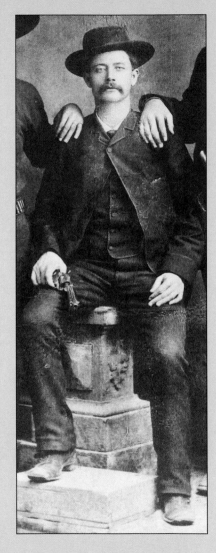

Ranger Dick Ware emerged from a barber-shop, bib around his neck and lather on his face. Ware dropped Barnes with a bullet to his head, and Ranger George Harrell opened fire as Bass and Jackson rode past.

A bullet punched into Bass's back and ripped out his stomach. When Bass fell off his horse, Jackson dismounted and braved a hail of lead to help Bass back into the saddle.

The two fugitives galloped into the approaching darkness, but soon Bass could ride no farther. He insisted that Jackson escape while he could. Jackson tied Bass's horse nearby, then rode into permanent anonymity.

Bass suffered through the night and was found lying under a tree by a posse the next morning. The outlaw was taken into Round Rock the following day, Sunday, July 21, 1878—his 27th birthday—where he was placed in bed and died.

Gunfighting Rookies

At an age when today's teens are in high school, several noted Western gunfighters engaged in their first shoot-outs.

15 years old

John Wesley Hardin

Wild Bill Longley

Ben Thompson

John Younger

16 years old

Cole Younger

17 years old

Billy the Kid

Killin' Jim Miller

18 years old

Charlie Bowdrie

Henry Brown

▼ Bob Younger

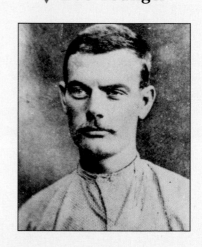

WILD BILL LONGLEY

1851–1878

"My first step was disobedience; next whiskey drinking; next carrying pistols; next gambling, and then murder, and I suppose next will be the gallows."

—*Wild Bill Longley*

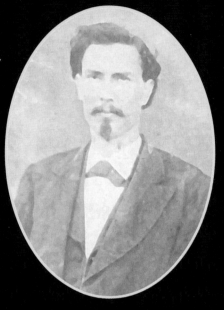

The Texas gunfighter was hanged for murder before a large crowd. But the rope slipped, and Wild Bill had to be hoisted back onto the gallows and rehanged.

The Execution of Black Jack Ketchum

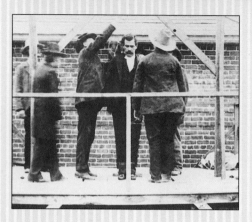

"I'll be in hell before you start breakfast boys," announced Black Jack from the gallows. "Let her rip."

Hard-drinking Texas cowboy Tom Ketchum, along with his older brother Sam, drifted into outlawry during the 1890s. Dark-complected and dark-haired, Tom was called "Black Jack" after another swarthy gang leader, Black Jack Christian (who was killed in Arizona in 1897).

The Ketchum Gang included Will Carver and Elzy Lay, outlaws who had ridden with Butch Cassidy's Wild Bunch. The gang robbed stores, post offices, stagecoaches, and trains. A merchant was slain in Texas, and Black Jack killed two people in an 1899 Arizona saloon fight.

A few days later the gang was jumped by a posse. Two officers were killed, and Lay and Sam Ketchum were wounded. Sam soon died of blood poisoning.

Three weeks later, in August 1899, Black Jack single-handedly stopped a train at Folsom, New Mexico, where his gang had previously robbed a train in 1897. He wounded the express messenger and conductor, but the conductor blasted Black Jack with a shotgun. His mutilated arm was amputated, and Black Jack Ketchum was hanged in Clayton, New Mexico, on April 26, 1901.

Black Jack Ketchum was the only person ever to be hanged in Union County, New Mexico. The *San Francisco Chronicle* reported his last words, "Goodbye. Please dig my grave very deep. All right; hurry up."

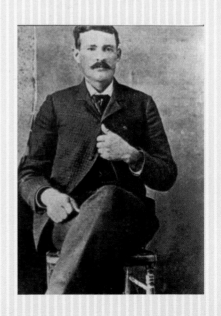

CLAY ALLISON

1840—1887

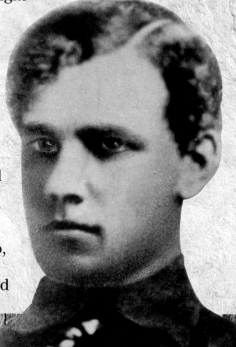

During the Civil War, Confederate doctors issued a rare medical discharge to Private Clay Allison of the Tennessee Light Artillery, citing a condition "of a mixed character, partly epileptic and partly maniacal." Although Allison moved west and became a successful trail driver and rancher, his "maniacal" side often erupted in murderous explosions.

In 1870 he led a New Mexico lynch mob, then he personally decapitated the lynched

murderer and placed his head on a pole. Four years later he killed gun-fighter Chunk Colbert in a saloon fight over a horse race and was suspected of poisoning the race judge.

"He never killed a man that did not need killing."

—*Clay Allison's gravestone*

In 1875 Allison led another lynch mob and again abused the corpse. Three days later he shot a man to death in the famed St. James Hotel in Cimarron, New Mexico. Allison also killed a Colorado deputy sheriff in an 1876 shootout in Las Animas.

But the hard-drinking gunfighter shot himself in the foot in 1881. And in 1887 he fell out of his wagon and suffered fatal injuries.

Henry and Winchester Rifles

Oliver Winchester, a successful shirt manufacturer from New Haven, Connecticut, ventured into unfamiliar territory when he purchased a bankrupt arms factory in 1857. Knowing little about firearms, he hired a gifted young gunsmith named B. Tyler Henry to produce a repeating rifle for his New Haven Arms Company.

Metallic cartridges, essential to such a weapon, were still in their early stages. Henry quickly perfected a metallic rimfire cartridge then began designing a rifle to use it.

Released in 1860, the .44-caliber Henry rifle carried 16 rounds in the tube beneath the barrel and another in the chamber. A lever attached to the trigger

The 1860 Henry repeating rifle, which was loaded from the mouth, carried 16 cartridges in the magazine tube and another round in the chamber.

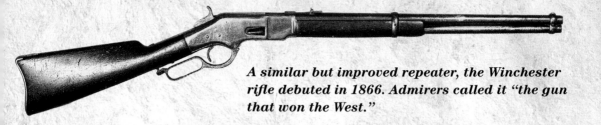

A similar but improved repeater, the Winchester rifle debuted in 1866. Admirers called it "the gun that won the West."

guard pumped cartridges from the tube into the chamber. The 17-shot Henry could be emptied in 11 seconds, and 120 rounds could be unleashed in less than six minutes.

An improved repeater, which could be loaded from the side of the breech, was introduced in 1866. It was the first of several successful models to bear the legendary Winchester name.

"You can shoot a Henry all week and not reload until Sunday."

—Saying about the Henry long-barreled repeating rifle

CHEROKEE BILL

1876—1896

As a teenager Cherokee Bill liked to drink and carouse. He shot his first man after a fistfight at a dance in Fort Gibson, Oklahoma, in 1894.

❦ ❦ ❦

During the next few months Cherokee Bill killed an officer then shot his brother-in-law to death for beating his wife, Bill's sister.

❦ ❦ ❦

While looting a depot Cherokee Bill killed the station agent, a conductor who tried to throw him off a train, and a bystander.

❦ ❦ ❦

Arrested while visiting a sweetheart, Cherokee Bill was tried and sentenced to hang. He killed a guard during an attempted jailbreak.

❦ ❦ ❦

On the gallows Cherokee Bill was asked if he had any remarks. He replied, "No. I came here to die, not to make a speech."

Crawford Goldsby, alias Cherokee Bill, was sentenced to hang after Judge Isaac Parker called the murderous teenager "a human monster."

TOM HORN

1860—1903

"Killing is my specialty. I look at it as a business proposition, and I think I have a corner on the market."

These are the chilling words of one of the West's most notorious hired killers. But before Tom Horn became an assassin, he was a **Western hero**—army scout, deputy sheriff, detective.

As a Missouri farm boy Horn became an avid hunter and outdoorsperson. A compulsive adventure seeker, he was drawn to the West in his teens. Horn mastered the cowboy's skills and became a champion competitor in early rodeos.

During the Apache Wars he enlisted as a packer or mule-

wrangler, fought in combat as a scout, and played a significant role in the final surrender of Geronimo. A decade later he returned to the army to scout for the Apache Kid, and in 1898 Horn went to Cuba as a chief packer for the Rough Riders.

After hunting outlaws for the Pinkerton Detective Agency, it seemed logical for Horn to accept employment as a stock detective for Wyoming cattle barons. But the big ranchers wanted rustlers eliminated, so Horn began to **stalk human prey.**

Firing from concealment at long range, he killed rustlers William Lewis and Fred Powell in 1895. Horn deliberately cultivated a lethal reputation, and often his appearance in a region inspired rustlers to depart for safer territory.

In 1900 Horn ventured into Brown's Park, a notorious haunt of outlaws. "I stopped cow stealing there in one summer," bragged Horn—after rustlers Matt Rash and Isom Dart were shot dead.

But the next year the assassination of 14-year-old Willie Nickell was blamed on Horn. Although his conviction was based on a trumped-up "confession" that would not be admitted in a modern court, Horn was hanged in Cheyenne one day before his 43rd birthday.

Butch Cassidy and the Sundance Kid

Butch and Sundance were the best-known members of the notorious Wild Bunch. Robert LeRoy Parker was born in Utah in 1866, the oldest of 13 children. His famous alias resulted from a job in a butcher shop and his admiration for rustler Mike Cassidy.

During the 1890s, "Butch Cassidy" served two years in the Wyoming State Penitentiary for rustling. After his release he led the Wild Bunch in a series of bank and train robberies. Between jobs the gang vacationed in such cities as Denver, San Antonio, and Fort Worth.

Cassidy's closest confederate was Harry Alonzo Longbaugh. Jailed in Sundance, Wyoming, while still a teenager, Longbaugh inevitably was nicknamed "The Sundance Kid." Along the outlaw trail he acquired a pretty mistress, Etta Place.

In 1901 the two outlaws and Place fled to South America, where Butch and Sundance apparently were killed a few years later. In 1969 their exploits were romanticized in the most charming Western ever filmed, *Butch Cassidy and the Sundance Kid*.

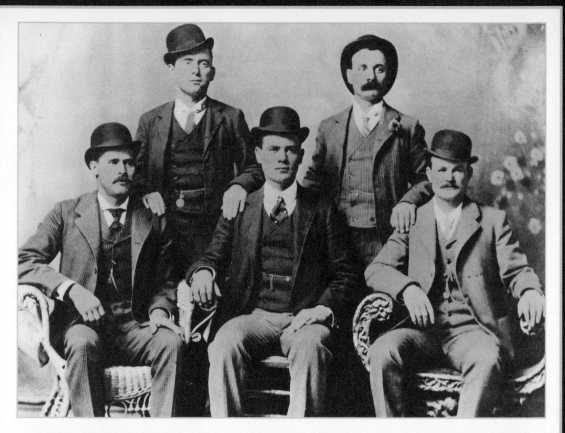

Members of the Wild Bunch on vacation in Fort Worth, December 1900

From left, seated: Harry Longbaugh—The Sundance Kid; Ben Kilpatrick—the Tall Texan; Butch Cassidy. Standing: Will Carver and Harvey Logan. This famous photo helped detectives track the outlaws.

CHAPTER TWO
Leaders and Legends

In John Ford's film *The Man Who Shot Liberty Valance*, Carleton Young proclaims,

"This is the West, sir. When the legend becomes fact, print the legend!"

"If it had not been for my years in North Dakota, I never would have become President of the United States."

—*Theodore Roosevelt*

COPYRIGHT 1899

Courier

COL. W. F. CODY
"BUFFALO BILL"

Sam Houston

1793—1863

Sam Houston lived twice among the Cherokees, who first nicknamed him "The Raven," then, during a low point in his life, "Big Drunk."

🐾 🐾 🐾

Distinguishing himself in combat under General Andrew Jackson, young Houston acquired an important patron. He was elected to two terms in Congress and two terms as governor of Tennessee.

🐾 🐾 🐾

Texas declared independence from Mexico on Houston's 43rd birthday, March 2, 1836.

🐾 🐾 🐾

At the age of 47, Houston married Margaret Lea, a 21-year-old preacher's daughter who bore him eight children and persuaded him to be baptized. At the creek where Houston was baptized, the preacher announced that his sins were washed away. Houston replied, "God help the fishes!"

🐾 🐾 🐾

"Old Sam Jacinto" was the first elected president of the Texas Republic in 1836. When Texas became a state in 1846 he served in the U.S. Senate and as governor.

🐾 🐾 🐾

General Houston won independence for Texas with a victory at San Jacinto on April 21, 1836. Within 18 minutes, 630 Mexican soldiers were killed and 730 captured. Only 8 Texans were killed and around 30 wounded—including Houston.

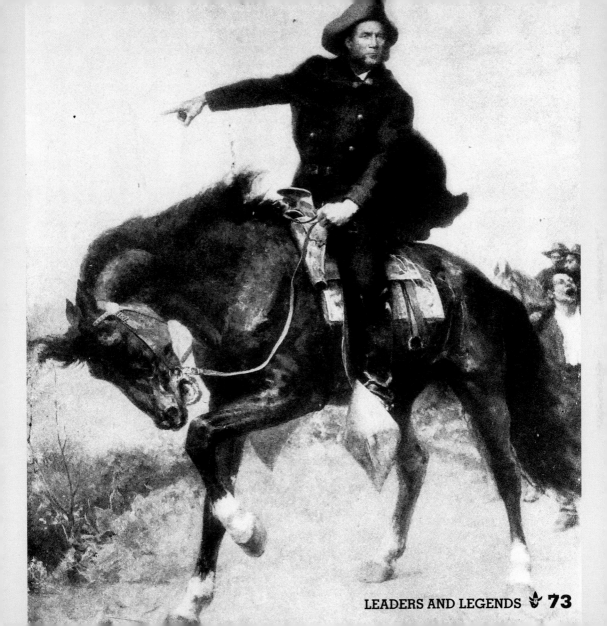

GEORGE CROOK

1828—1890

Unorthodox, courageous, and resourceful, George Crook was known among his Native American foes as "Gray Fox." Beginning shortly after his graduation from West Point in 1852, Crook battled Native Americans during four different decades.

The innovative young officer learned to fight frontier-style, emulating the guerrilla tactics of the warriors and living off the land while in the field. Other unprecedented practices for the times included drilling his soldiers and instructing them in shooting at targets.

The Civil War interrupted Crook's frontier service, and by war's end he had been promoted to major general of volunteers. He returned to the West a lieutenant colonel of regulars. But Crook was so effective he was soon elevated to colonel, and then in 1873 to brigadier general.

Two keys to Crook's success against various hostile tribes were his use of pack trains, which provided far greater mobility in the field than wagon trains, and the liberal employment of Native American scouts, who were eager to settle old scores with enemy tribes.

Crook was an avid outdoor enthusiast, habitually ranging ahead of his column on solitary hunting and scouting forays. His personal probes familiarized him with the terrain where he would campaign, and he regularly provided fresh meat to his comrades.

In 1888 Crook was promoted to major general, but two years later he died at age 60. Some of his former Native American opponents wept at the news, and Chief Red Cloud stated, "He never lied to us."

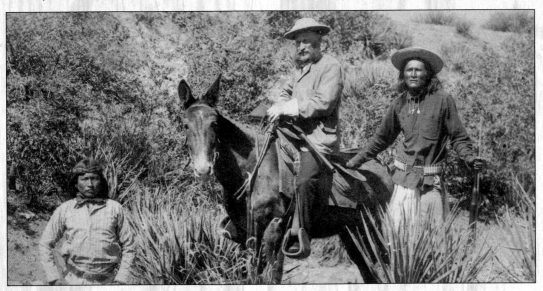

General Crook is shown with Native American scouts Dutchy (left) and Alchesey. In the field, Crook shunned uniforms, rode a mule, wore a straw hat or cork helmet, and carried a shotgun or hunting rifle.

Long-Handled Underwear

The common underwear of the nineteenth century was a one-piece, long-sleeved, long-legged suit with a "trapdoor" in the rear. These red or white suits were called *long johns* or *long handles*. Long johns not only added insulation against winter cold, but also provided a necessary layer during hot weather, when wool against the flesh would have been unbearable. Sweat-soaked long handles had a cooling effect. Of course, cowboys did not often bathe or wash their clothes, especially on the trail, and the odor of cowboy long johns was deservedly notorious.

Chaps

Mexican cowboys, called *vaqueros*, originally laid cowhides over their saddles and folded them over their pants for protection after mounting their horses. From this awkward arrangement evolved *chaparejos*—leather leggings that buckled in the back at the waist and protected their legs while riding through heavy brush or cactus country.

Cowboys readily adopted chaparejos from their Mexican counterparts, but they shortened the name to chaps. The chaps provided protection not only

from cacti and brush but also from horse bites, corral poles, barbed wire, and rope burns. During the winters on the cold northern ranges, cowboys pulled on woollies—sheepskin chaps—for warmth.

Saddle

The saddle was the cowboy's workbench. He might spend 14 or more hours on horseback, and light eastern saddles were inadequate for such work. In the 1830s California vaqueros had developed a large saddle based on the Spanish war saddle.

With the spread of cattle ranching after the Civil War, the western stock saddle evolved rapidly. This saddle was built with leather around a wooden "tree," or frame. A light saddle horn placed in front secured a lariat, while wide leather fenders, extending from seat to stirrup, protected the rider's legs from horse sweat.

A well-crafted saddle ensured the comfort of both horse and rider. A cheap saddle could make a horse's back sore within 10 miles, but an expert rider could cover 70 miles in a day with a good saddle on his horse. In a time when cowboys were paid about $30 a month, it was not unusual to put a $40 saddle on a $10 horse!

GEORGE ARMSTRONG CUSTER

1839—1876

During his boyhood in Ohio, "Autie" Custer was so impressed by his father's participation in a local militia company that he practiced near the soldiers wearing a little uniform and carrying a toy musket. Young Custer developed a tireless constitution and an affinity for horses while working at his father's blacksmith shop.

At West Point he was an inept pupil, piling up demerits for slovenliness and tardiness and graduating last in his class of 34. He was a superb horse rider, however, and as a

Custer became the youngest general of the Union Army at age 23.

Civil War cavalry member he proved audacious. Custer led slashing charges that earned him promotions, publicity, and the admiration of such influential people as Generals Philip Sheridan and Ulysses S. Grant.

Custer's brilliant combat performance vaulted him to the rank of major general of volunteers. In 1864 the "Boy General" married lovely Elizabeth "Libbie" Bacon.

Reduction in rank followed the war, but General Sheridan secured for Custer the lieutenant-colonelcy of the newly organized 7^{th} Cavalry. Since the colonel was rarely present, Custer commanded the regiment in practice. Although many of his officers and enlisted members regarded him as a disciplinarian, his strictness paid off: Custer molded the 7^{th} into a crack regiment with a rigorous training program. In 1868 he led the 7^{th} in a bloody conquest of Black Kettle at the Battle of the Washita.

In the field Custer maintained a large, luxuriously appointed tent, and Libbie sometimes accompanied him on campaigns. When she stayed behind, Custer wrote her long letters—including one 80 pages long—and once he was court-martialed for leaving his command to ride to her side.

In 1876 Custer led the 7^{th} to disaster at the Little Bighorn River where he was killed. The next year his body was exhumed from the battlefield site and reinterred at West Point.

Libbie remained devoted to his memory and wrote several books about their mutual experiences in the service. She died in New York City in 1933 at the age of 92.

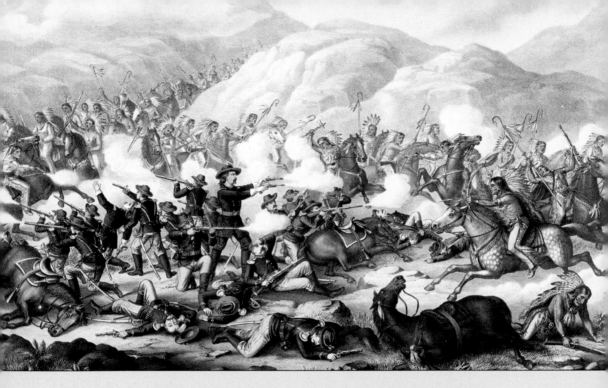

Custer's Last Stand
June 25, 1876

This painting shows the traditional version of the Battle of the Little Bighorn, with George Armstrong Custer falling with the last of his comrades. More than 260 soldiers of the 7th Cavalry died after Custer divided his command. Surviving units dug in and fought off superior numbers for two days, and 24 troopers earned the Medal of Honor.

Five Best Cavalry Movies

They Died with Their Boots On (1942) ▶

Errol Flynn as George Armstrong Custer

Fort Apache (1948)

Henry Fonda as the Custer character

She Wore a Yellow Ribbon (1949)

John Wayne. Movie begins with news of Custer's fall

Rio Grande (1950)

John Wayne as a Ranald Mackenzie character

Ulzana's Raid (1972)

Burt Lancaster as a scout in the Apache Wars

RANALD MACKENZIE

1840—1889

Ranald Slidell Mackenzie was the Army's top regimental commander during the Indian Wars. His father was a distinguished naval officer, and Ranald graduated first in his West Point class of 1862.

Mackenzie distinguished himself in Civil War combat and was wounded six times. He became a major general of volunteers at the age of 24. General Ulysses S. Grant called Mackenzie "the most promising young officer in the army."

After the Civil War, Mackenzie was appointed colonel of the 41st Infantry, an African-American regiment. But cavalry, not infantry, would spearhead western campaigns against horse warriors, and in 1871 he assumed command of the 4th Cavalry.

Innovative, hardworking, and a stern disciplinarian, Mackenzie transformed the 4th into the Army's finest fighting outfit against Native Americans. Mackenzie led his regiment in penetrations of the Comanche and Kiowa heartland in West Texas, and an 1873 campaign into Mexico brought security to lower Texas. The next year Mackenzie's victory at the Battle of Palo Duro Canyon drove Comanches onto the reservation. That victory proved to be a major turning point in the Red River War.

During the next several years Mackenzie and the 4th were the Army's troubleshooters. They were sent to Camp Robinson, Nebraska, to reestablish control over the Red Cloud Agency. Returning to Texas, they halted rustling forays by raiders from Mexico. Ordered to Arizona by General Philip Sheridan in the late 1870s, Mackenzie and his crack regiment took only five weeks to restore order between Apaches and Navajos.

Mackenzie was promoted to brigadier general in 1882, and the next year the 43-year-old bachelor became engaged to a San Antonio widow. Tragically, his happiness and success were spoiled by severe mental deterioration caused by overwork and long-term effects of his multiple wounds.

Declared insane, General Mackenzie was placed on the retired list in 1884. His sister cared for him for the next few years until his death at the age of 48. Mackenzie was interred at West Point alongside other military greats.

NELSON MILES

1839—1925

For a decade and a half Nelson Miles was an efficient and relentless Native American fighter who successfully employed infantry in wars otherwise dominated by cavalry.

A tall, handsome officer, Miles was brave, aggressive, and well organized. But he also was vain, pompous, and ruthless in his personal ambitions. He acquired friends strictly for their value as contacts. He hated to give credit to other officers, and he was deeply jealous of West Point graduates. Miles earned considerable enmity with his harsh criticisms of other officers, and throughout his career he was embroiled in one feud after another.

A 21-year-old Boston clerk when the Civil War erupted, Miles raised a troop of infantry. Bold and courageous, he was wounded four times, won the Medal of Honor, and vaulted in rank from lieutenant to major general of volunteers. In spite of his self-promotion, General Miles distinguished himself in combat during the Civil War, the Indian Wars, and the Spanish-American War.

Reduced to colonel after the Civil War, Miles was determined to reach the top of the frontier army. His 1868 marriage to Mary Sherman, niece of the army general and of Ohio Senator John Sherman, gave him invaluable contacts.

In 1874 General Sherman assigned Miles to lead a column in the Red River War. In 1876 his command effectively pressured the victors over George Armstrong Custer's 7th Cavalry. The next year Miles successfully intercepted Chief Joseph's Nez Percé. In 1878 Miles took time out from a vacation to skirmish with Bannocks, and two years later he was promoted to brigadier general.

In 1886 General Miles engineered the final surrender of Geronimo. In 1890 he received a second star, and five years later he became commander-in-chief of the Army. During the Spanish-American War Miles seized Puerto Rico with a masterful campaign, and in 1901 he was promoted to lieutenant general.

When Miles was 77 he tried to volunteer for service in World War I. At the age of 85, while attending the circus with his grandchildren, he was felled by a fatal heart attack during the National Anthem.

In 1874 Miles led a column in the Red River War.

Ranching in the West

"These steers are walking fifty-dollar bills."
—Oklahoma rancher Clem Rogers, father of Will Rogers

❧ ❧ ❧

Almost every chuck wagon meal on a trail drive featured "Pecos strawberries"
(beans) and "overland trout" (bacon).

❧ ❧ ❧

A grizzled southwestern rancher opined: "One thing I'll say for the West is that in this
country there is more cows and less butter, more rivers and less water, and you
can look further and see less than in any other place in the world!"

❧ ❧ ❧

"He was so tall, he had to shorten his stirrups to keep his feet from draggin'."
—Cowboy slang

❧ ❧ ❧

"Hasten forward quickly there!"
**—Harvard-educated rancher Theodore Roosevelt, shouting a command
that had his cowboys convulsing with laughter**

Religion in the West

At the insistence of his wife, legendary cattle rancher Charles Goodnight joined the church shortly before his death at 93. When asked what denomination it was, Goodnight answered:

"I don't know, but it's a damned good one."

❦ ❦ ❦

At a Tucson saloon, Bob Leatherwood bet a man that he could not recite the Lord's Prayer.

"Hell yes, I can!" the man replied indignantly.

"Now I lay me down to sleep, I pray the Lord my soul to keep . . ."

"You win, you win!" Leatherwood broke in, shoving the money across the table.

Best Cattle Brands

A brand was read top to bottom, left to right, and outside in. By the time ranch children started school, they already knew the alphabet.

Top to bottom, left to right, the Bar-B-Que brand spelled out one of the Southwest's favorite foods.

It was often Too Hot in ranch country.

Western cattle rarely were Too Fat.

Teddy Roosevelt's Maltese Cross brand. Dakota cowboys, assuming that "Maltese" was the plural of something, usually called the ranch the "Maltee."

Texas rancher J. H. Barwise devised a brand, Bar Ys, that would make clear who owned the beef. . . .

. . . as did Jack Barber. . . .

Texas rancher T. J. Walker philosophized that "a man's a fool to raise cattle."

KT ...and Katie Barr.

ICU The rustler's altered version of the original brand.

IC Brand of a Texas rancher who suffered thefts by a nearby rancher.

ICU2 After ordering his cowhands to steal the cattle back, the first rancher added another registered brand.

Spanish wranglers brought branding irons to the New World, and Mexican vaqueros taught the practice to Anglo ranchers.

Lariat

In Spanish, *la reata* means "the rope." Vaqueros used a rope about 60 feet long made of braided rawhide. Texas cowboys named this essential tool a *lariat* but used woven grass lariats about 40 feet in length.

After lassoing an animal, the loose end was "dallied" around the saddle horn in a half hitch. If a steer lunged, a vaquero might lose a finger between the lariat and saddle horn. Vaqueros liked to exhibit a missing finger or two as a badge of their profession, but American cowboys showed off all ten fingers as a demonstration of their superior skill with a lariat.

Spurs

Spurs are essential to controlling a horse, especially for encouraging it to cross a rough place it is reluctant to tackle or to signal it for quick stops and turns. Cowboys are horse lovers, and they file off sharp rowel points—revolving disks with sharp points at the end—so that the animal will be prodded but not cut.

For dressier occasions, many cowboys bought a pair of engraved silver spurs with tooled leather spur straps. Jinglebobs sometimes were attached to the shank of the spurs, and heel chains kept the spur from riding up the boot.

Sabers

Reminiscing about an 1857 clash with a large Cheyenne war party, trooper Robert Peck recounted that Colonel E. V. Sumner tried to create a panic in the enemy's rank.

According to Peck, Sumner "roared out 'Sling-Carbine!' Then immediately, 'Draw-Saber!' and we knew the old man was going to try a saber charge on them. I noticed with some surprise that when the command 'Draw Saber' was given...and our three hundred bright blades flashed out of their scabbards, the Cheyennes, who were coming on at a lope, checked up. The sight of so much cold steel cooked their ardor...."

During the 1850s, the cavalry in Texas often used their sabers for close-quarter fights with Comanches and Kiowas. After the Civil War, warriors increasingly avoided horse-to-horse battle with the "Long Knives." Although sabers were required with dress uniforms, they were generally left behind when troopers went on patrol late in the nineteenth century.

Boots

Cowboys returning from the Civil War wore flat-heeled, broad-toed military boots. By the late 1860s, however, cowboy boots were being made with high heels, narrow toes, and thin soles. The thin soles gave the rider the feel for the stirrup. The narrow cut allowed the cowboy to catch the stirrup of a wheeling horse, and if the rider was thrown, it gave him a better chance of slipping his boot out of the stirrup to avoid being dragged to death.

The high heels permitted a cowboy to brace his feet in the stirrups while on horseback or to dig in his heels when roping on foot. Intricate stitching added decoration but also stiffened the tops so that they better withstood the constant wear of the stirrup.

BEN THOMPSON

1842–1884

During the early years of the Chisholm Trail, cattle herds from Texas were driven to Abilene, Kansas. Texas cowboys eagerly sought recreation in the Bull's Head Saloon, owned by Ben Thompson.

Thompson was one of the most dangerous gunfighters in the West. Beginning with adolescent shooting scrapes in Austin, Thompson engaged in gunplay from the 1850s through the 1880s. The gambler from Texas fought in at least 14 shoot-outs, killing half a dozen people and wounding several others.

During the Civil War, young Thompson joined the Confederate Army, serving in Texas, Louisiana, and New Mexico. He married during the war, and after the Confederate surrender he served for a time in Mexico under the Emperor Maximilian.

As a gambler, saloonkeeper, and frequent shootist, Thompson spent a couple of years in the Texas penitentiary during Reconstruction. Once he was out, he became attracted to the action in Kansas cattle towns and opened the Bull's Head Saloon in Abilene, operated another saloon

in Ellsworth, and gambled in Dodge City.

But a buggy accident in 1871 crushed his son's foot and caused the amputation of his wife's arm. Thompson moved his family back to Austin, where he was elected city marshal in 1881. Although he proved to be an excellent official, he resigned the next year after a fatal gunfight occurred in San Antonio.

Thompson often had to rescue his hard-drinking, fast-shooting younger brother, "Texas Billy," from serious troubles. Ben's own troubles ended in 1884, when he and gunfighter King Fisher were assassinated in San Antonio.

BEAR RIVER TOM SMITH

1830—1870

Thomas J. Smith, a worker on the first transcontinental railroad, quelled a riot in Bear River City, Wyoming, in 1868. He earned the nickname **"Bear River Tom"** and became a **railroad troubleshooter.**

After serving as **town marshal** of Greeley, Colorado, Smith accepted a similar position in the wild cattle town of Abilene, Kansas. Smith was known for **refusing to use a gun,** even during dangerous situations. Once he marched up

to a burly fellow known as **Wyoming Frank** who held a gun on him. Unflinching, the two-fisted Smith **slugged** Wyoming Frank, then **pistol-whipped** him with his own gun.

But after only six months on the job, Marshal Smith was **shot in the chest** while trying to make an arrest. After a furious struggle with the shooter, **Smith was finished off with an ax.** Abilene's next marshal would be a two-gun fighter—**Wild Bill Hickok.**

Thomas J. Smith
Marshal of Abilene, 1870.
Died, a Martyr to Duty, Nov. 2, 1870.
A Fearless Hero of Frontier Days Who In Cowboy Chaos Established the Supremacy of Law.

—*Bronze plaque in Abilene cemetery*

WILD BILL HICKOK

1837—1876

Frontier adventurer Wild Bill Hickok became the West's most famous gunfighter: The Prince of Pistoleers.

A tall man with an athletic physique, he was a flamboyant dresser who affected shoulder-length hair and sweeping mustaches. Cherokee Gross recalled that his old friend "always had a mistress."

Wild Bill wore a badge in several Western towns and served as a daring army scout during the Civil War and Native American conflicts. He also worked as a teamster and stagecoach driver, amplified his legend by performing in Wild West shows, and killed at least seven people in a series of widely publicized gunfights.

His first shoot-out was in 1861 involving a melee with Dave McCanles, and each one was backed by two friends. Wild Bill killed McCanles and wounded his two allies, who were finished off by Hickok's allies. The tale grew as it was told and retold. Ultimately the story told of how Hickok overcame several wounds to wipe out McCanles and nine members of his "party of ruffians."

A classic gunfight occurred in 1865 in the town square at Springfield, Missouri, when Hickok and gambler Dave Tutt confronted each other before an expectant crowd. At a distance of 75 yards Tutt drew a pistol and squeezed off a shot that went wild. Hickok steadied his own revolver with both hands then fired a ball into Tutt's heart.

Other gunplay included three shoot-outs in Hays City, Kansas, where Hickok was elected county sheriff. In 1871 Wild Bill was appointed city marshal of Abilene. Surrounded by hostile cowboys, Marshal Hickok was faced by gambler Phil Coe who pulled out a revolver and fired a shot that cut through Wild Bill's coattails. Hickok drilled Coe in the stomach, and when he

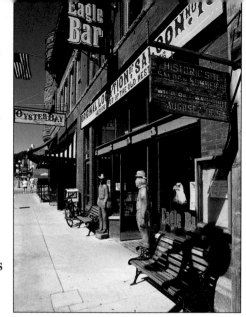

The chair Wild Bill was sitting in when Jack McCall shot him is in a glass case above the door to Saloon No. 10 in South Dakota.

glimpsed movement in the threatening crowd, he whirled and fired—into the head of Deputy Mike Williams. Grief stricken over shooting his own deputy, an anguished Wild Bill scattered the crowd and shut down the town.

The Prince of Pistoleers never again fired a shot in anger. In 1876 he gravitated to the Black Hills mining boomtown of Deadwood, where he became a regular at the gambling tables of Saloon No. 10. There he was shot in the back of the head by Jack McCall. Hickok was holding two pair—aces and eights—which became known as the Dead Man's Hand.

CALAMITY JANE

1852—1903

Calamity Jane did not look like Doris Day, Jane Russell, Yvonne de Carlo, or any of the other Hollywood actresses who have portrayed her on the silver screen. She had a figure that could most charitably be described as sturdy.

Photographs reveal that she liked to wear buckskins or leather chaps, and she donned a slouch hat even when she sported a dress. The shape of her nose suggested that it might have once been flattened by a fist. She drank to excess, cursed habitually, chewed tobacco, worked as a sporting lady—and somehow became the most readily identifiable woman of the Old West, even though it was not known how she acquired her famous sobriquet.

Martha Jane Canary was born in Missouri and claimed to have been born in 1852, although some publications state 1844. By 1873 she was working at a bordello near Fort Laramie in Wyoming. In 1875 and 1876 she marched as a teamster with military expeditions, but both times her gender was discovered and she was fired. During the latter year she was thrown behind bars in Cheyenne, and she apparently served other jail terms for disturbing the peace during her lifetime.

Jane ventured to Deadwood, South Dakota, in 1876, not long before Wild Bill Hickok was slain there. She claimed a long and intimate—and highly unlikely—association with the famous gunfighter.

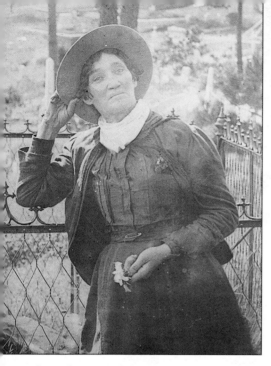

In Deadwood, Jane displayed a classic heart of gold by assuming the unlikely role of nurse. Sometimes working for no pay, she cared for a smallpox patient, a stabbing victim, a dying girl, and a premature baby. A little more in-line with her image, Jane also hired out as a bullwhacker in the Black Hills, cracking a whip over large teams of oxen.

After 1880 she left Deadwood and spent the rest of her life drifting. In 1885 she married Clinton Burke, and two years later bore him a daughter. In 1896 Burke fled town and his family after embezzling money. Their daughter was taken to a convent, probably in North Dakota, and Jane continued to drift.

Jane made a few stage appearances as a Western scout and cowgirl, but by then she was haunted by alcoholism. In 1901 she was found ill and drunk in a house of prostitution in Horr, Montana. Two years later she collapsed in Terry, a mining town near Deadwood. Delirious, she spoke of her daughter, then died on August 1, 1903.

Jane's friends arranged to have her interred within 20 feet of Hickok's grave, claiming her dying wish was to be buried next to Wild Bill. They even changed the date of her demise to August 3, 1903, the 27th anniversary of Wild Bill's death.

Hat

The broad-brimmed Western hat evolved from the big sombreros worn by Mexican vaqueros. John B. Stetson began manufacturing large felt hats for Westerners in the 1860s, and when he died in 1906, his factory was turning out two million Stetsons a year.

A cowboy's "John B." was the first thing he put on in the morning and the last thing he took off at night. The crease of his John B. crown and the angle of his brim expressed his personality. A cowboy's hat offered protection from sun, rain, hail, sleet, and snow. In frigid weather, the brim could be pulled down over his ears with a big bandanna to prevent frostbite. The crown could double as a water bucket or a grain bag for his horse. When starting a campfire, he used the hat to fan the flame. Waving a broad-brimmed John B. could turn a rambunctious steer or horse, and if a cowboy needed a little daytime sleep, the hat was a perfect eyeshade.

Cigarette Makin's

Old-time cowboys never smoked "tailor-mades." They always rolled their own cigarettes from "makin's." A cowboy carried a sack of Bull Durham tobacco and a "Bible"—a packet of

cigarette papers. The Bible was also called a "prayer book" or a "dream book," while tobacco was known as "heifer dust," "rest powder," or "Scandihoovian dynamite."

If a cowboy ran out of makin's, he could ask another cowhand and never be turned down, unless the refusal was an intentional insult. Makin's usually were carried in a vest pocket. In the saddle, it was difficult to reach into a pants pocket, and many shirts were collarless pullovers with only two or three buttons and no pockets. Most cowboys wore vests, and soon a "stockman's vest" was manufactured with four front pockets.

Bandanna

As with other parts of his outfit, the cowboy put his colorful bandanna to a great many uses. It was commonly pulled over the nose and mouth to act as a dust filter when riding drag during a trail drive—or to act as a disguise when robbing a stagecoach or bank. Under a blazing sun, the bandanna could shield the back of the neck, or it could be dipped in water and wadded up beneath the hat crown so the cowboy could cool off. A big bandanna could serve as a towel, a sling, or a tourniquet.

Sheriff A. J. Spradley's doctor found a unique medical use for a bandanna when the Texas official was shot in 1884. The bullet went in Spradley's front and tore out his back, normally a fatal wound in the 1880s. The resourceful physician soaked a silk bandanna in whiskey and used a ramrod to work it back and forth through the bullet hole to cleanse the wound. Spradley lived for 56 more years.

WYATT EARP

1848–1929

"In his prime, Wyatt was greased lightning," recalled his brother James Earp. "I saw a couple of fights where guys swung at him and only hit thin air. And, he had a punch like a mule, with those long arms. Virge and I would call him the Earp ape."

"There were few men in the West who could whip Earp in a rough-and-tumble fight 30 years ago," wrote Earp's friend, Bat Masterson, in 1907.

Although Wyatt Earp is remembered as a fast-shooting hero of the gunfight at the O.K. Corral and the violent aftermath, he preferred to use his fists as a law officer. When Wyatt was the young constable of Lamar, Missouri, he and three of his brothers "had a 20-minute street fight" with five adversaries.

When he worked as a cattle town police officer in Wichita and Dodge City, Earp's weapon of choice in making routine arrests was a clenched fist. If he used a revolver, it was to "buffalo" a troublemaker—hit him over the head with a gun barrel.

Not until he was 30 did Earp fire a gun in anger. In an exchange of shots with drunken cowboys in Dodge City, either Earp or fellow officer Jim Masterson, Bat's brother, hit Texan George Hoy in the arm. Infection set in and Hoy died a few weeks later.

Wyatt did not unlimber his gun again for three years, until October 26, 1881, near Tombstone's O.K. Corral. Wyatt, his brothers Morgan and Virgil, and Doc Holliday gunned down Billy Clanton and Frank and Tom McLaury. Morgan, Virgil, and Doc were each hit, and Wyatt was the only one on the scene unscathed.

After Morgan and Virgil were ambushed in revenge, Wyatt led a vendetta. Riding with him were his youngest brother Warren, Holliday, Sherman McMasters, and Turkey Creek Jack Johnson. At least three assassins were killed during Wyatt's vengeance ride.

Late in life Earp lived in Los Angeles, and he fruitlessly attempted to have his adventures told in film or book form. But it wasn't until after his death that the public became fascinated with him, and there were movies, books, and even a popular television series.

BAT MASTERSON

1853—1921

Bartholomew Masterson became known as Bat for one of three reasons: he whacked lawbreakers over the head with a cane, he changed his middle name later to Barclay, or because he was a battler.

Born in Quebec, Canada, he was raised on family farms in New York, Kansas, and Illinois. At 18 Masterson gravitated to lively Dodge City, Kansas. He hunted buffalo long enough to help stand off Quanah Parker's Comanches at Adobe Walls in

Masterson standing with his friend Wyatt Earp in 1876.

1874 then scouted for General Nelson A. Miles. Back in Dodge City he ran a saloon and served for two years as sheriff of Ford County.

At the same time that Bat was elected sheriff, his older brother Ed was appointed town marshal of Dodge City. Ed was a popular law officer, but he was killed in a gunfight with two Texas cowboys. A younger brother, Jim, was a Western law officer for 15 years and fought in numerous shoot-outs.

Although Masterson spent 30 years of his adult life in the West, he engaged in just three gunfights. The deadliest fray occurred in the Texas panhandle in 1876 when Masterson was 22. Saloon girl Molly Brennan was involved in a confrontation between her two suitors, Masterson and Corporal Melvin A. King of the 4th Cavalry. Brennan was slain along with King, while Masterson was severely wounded.

Beginning in the 1880s Masterson headquartered in Denver, gambling and dabbling in journalism. He became an avid outdoor enthusiast and was a noted official and promoter of prizefights.

In 1902 Masterson and his wife moved to New York City, where he spent the last two decades of his life frequenting the nightspots of the Great White Way and skillfully writing sports for the *Morning Telegraph*. While composing a column on October 25, 1921, he died of a heart attack at his newspaper desk.

Doc Holliday

1851—1887

John Henry Holliday was the son of a prosperous Georgia family. An 1872 graduate of the Pennsylvania College of Dental Surgery, Dr. Holliday opened a practice in Atlanta but soon was diagnosed with tuberculosis.

Moving west for his health, Holliday abandoned dentistry for gambling. He appeared in numerous western boomtowns during their heydays, including Dallas and Fort Griffin in Texas, and Denver, Leadville, and Pueblo in Colorado.

A heavy drinker with a bad temper, Holliday became embroiled in eight gunfights, most famously at the O.K. Corral. During these altercations he shot several people, four fatally.

Holliday's female companion was a prostitute known as Big Nosed Kate, a Hungarian immigrant who died in 1940 at the age of 90.

His health undermined by alcoholism and tuberculosis, Holliday died at 36. Realizing that he was about to die peacefully in bed, he gasped, "This is funny."

Bat Masterson on Doc Holliday:

"Holliday had a **mean disposition** and an **ungovernable temper,** and under the influence of liquor was a **most dangerous man.**"

"Physically, Doc Holliday was a **weakling** who **could not have whipped** a 15-year-old boy. . . [which] was perhaps why he was **ready** to resort to a **weapon** of some kind whenever he got himself into difficulty."

"His whole **heart** and **soul** were wrapped up in Wyatt Earp and he was **always ready** to **stake his life in defense** of any cause in which Wyatt was interested."

PAT GARRETT

1850–1908

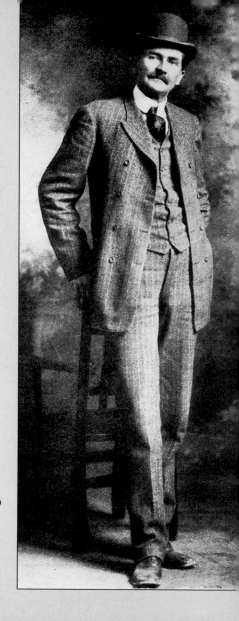

When he triggered a bullet into the heart of Billy the Kid on the night of July 14, 1881, Pat Garrett won a permanent niche in the front rank of frontier officers.

Patrick Floyd Garrett was raised on a Louisiana plantation. But his parents died after the Civil War, and the lanky teenager went west in 1869.

Garrett spent the next several years as a Texas cowboy and buffalo hunter. In 1876 during a brawl in a buffalo hunters' camp, Garrett was forced to shoot a skinner named Joe Briscoe. As Briscoe lay dying, he reduced Garrett to tears by asking, "Won't you come over here and forgive me?"

Garrett drifted to Fort Sumner, New Mexico, where he married in 1879. His teenage bride died during childbirth, but he quickly remarried and began raising a large family.

By 1880 the Lincoln County War had raged for two years. Garrett was elected sheriff to restore order in general and to halt the crime spree of Billy the Kid in particular. The Kid was a daring killer and horse thief with many friends who helped him elude capture, but Sheriff Garrett launched a systematic, relentless manhunt. Two of the Kid's closest companions were killed and Billy was arrested, but he shot two guards and escaped. Garrett finally tracked down the Kid and killed him.

There was immediate criticism for shooting Billy the Kid without warning and in a darkened room. Garrett was forced to hire a lawyer to collect reward money posted for the Kid, and he was not renominated at the next election.

In ensuing years Garrett owned or managed several ranches. From 1884 through 1885, he headed a special force of Home Rangers against rustlers in the Texas panhandle. In 1898, while serving as sheriff of Dona Ana County, Garrett engaged in a wild shoot-out with suspected killers.

Garrett finally moved his family to a ranch east of Las Cruces. But he became embroiled in a feud with a neighbor, and in 1908 the 57-year-old Garrett was murdered.

JUDGE ROY BEAN

1825?—1903

Justice of the Peace Roy Bean reigned as the "Law West of the Pecos" for two decades, holding court in his saloon.

❦ ❦ ❦

In 1892 Texas Governor James Hogg wrote Bean that after ten years he had never sent the state its share of the fees and fines he had collected. Judge Bean replied,

"Dear Governor: You run things up in Austin and I'll run them down here. Yours truly, Roy Bean."

❦ ❦ ❦

During an inquest, a revolver and $40 were found on the deceased. Judge Bean fined the corpse $40 for carrying a concealed weapon and confiscated the pistol for use by the court.

❦ ❦ ❦

Judge Bean once freed an Irishman accused of killing a Chinese railroad worker after searching his single law book and determining that the statutes "did not say it was against the law to kill a Chinaman."

❦ ❦ ❦

In 1896, although prizefighting was illegal in Texas, Bean staged a heavyweight championship between Bob Fitzsimmons and challenger Peter Maher. Bean built a ring on a sandbar of the Rio Grande, just south of town. A large crowd saw Fitzsimmons knock out Maher in the first round.

Bean was **infatuated** with actress **Lillie Langtry**, also called **"The Jersey Lilly."** He wrote the famous beauty that he had named his West Texas hamlet **"Langtry"** in her honor.

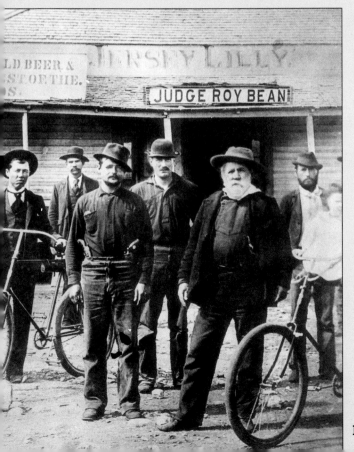

When she offered to pay for a public drinking fountain, he politely declined: *"If there's any-thing these hombres of Langtry* **don't drink,** *it's water."*

Judge Bean (in the beard) is shown in front of his saloon, The Jersey Lilly. He named the saloon after actress Lillie Langtry.

Best Cowboy Cures

Asthma: Catch a frog. Pry open the frog's mouth, and blow your breath into it. This must be done before daylight. The frog will die before sundown, but the asthma will go into the frog and never bother you again.

Colds: Vaqueros took red chili peppers, swallowed whole.

Cuts: These will heal if you let your pet dog lick them.

Dog bite: Apply hair from the dog—or else he'll bite you again.

Earache: Melt the grub of a dirt dauber into a spoon and pour it into the ear.

Fever blister: Put your little finger into your ear and get a little earwax, then rub it on the blister.

Hiccups: Have somebody pull out your tongue until it bleeds a little.

Hives: Make a tea of sheep manure; drink when warm.

Indigestion: Eat the dried lining of a chicken gizzard.

Labor pains: Hold the sharpened edge of an ax against the woman's stomach. The ax "cuts" her pain and takes her mind off her troubles.

Lockjaw: Drink cockroach tea.

Measles: Roast a mouse and eat it.

Pink eye: Wash sore eyes with cowboy urine.

BILL TILGHMAN

1854—1924

Bill Tilghman's Wild West adventures began almost as soon as he was born on July 4, 1854. He was only a few weeks old when his head was grazed by an arrow during a Sioux attack.

Raised on the Kansas farm of his parents, he became an excellent shot. Bill left home when he was 16 to hunt buffalo, killing nearly 12,000 beasts during the next five years.

Tilghman married in 1878 and began ranching near Dodge City, although his place soon was burned during a Cheyenne uprising. In 1884 he was appointed city marshal of Dodge City, beginning a varied and distinguished law enforcement career.

During four decades as a peace officer Tilghman was involved in several shoot-outs. But his most famous exploit as an officer was his single-handed—and bloodless—arrest of Bill Doolin, leader of the Oklahombres gang in 1896.

In 1900 Tilghman was elected sheriff of Lincoln County, Oklahoma, where he raised four children after the death of his first wife. In 1903 Sheriff Tilghman married a 22-year-old schoolteacher. Zoe Tilghman learned that "Bill habitually slept with a loaded .45 under his pillow." Undaunted by his bedroom hardware, Zoe bore him three sons.

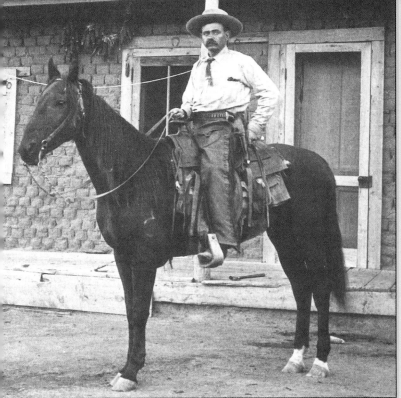

Ever ready for action, Tilghman wore his revolvers butts-forward for a crossdraw while in the saddle.

During the first decade of the twentieth century, Tilghman helped film a few Western movies and won election to the Oklahoma senate. In 1911 he accepted an appointment as police chief of Oklahoma City, and within two years he cleaned up the state capital.

In 1924, at the age of 71, Tilghman answered another call to duty in Cromwell, Oklahoma, a lawless oil boomtown. Chris Madsen prophetically advised his old friend not to take the assignment. Tilghman shrugged, "Better to die in a gunfight than in bed someday . . ."

Sadly, Tilghman was gunned down in the street, and his killer was acquitted by a jury. The murderer was shot dead eight years later, and Zoe observed, "No jury on earth can acquit him now."

STAGECOACH MARY

1832—1914

The stagecoach driver stood six feet tall and weighed 200 pounds, smoked cigars, drank whiskey, never ducked a fight, and packed a .38 in addition to a double-barreled shotgun. The stagecoach driver was named Mary.

Mary Fields was born into slavery in Tennessee. By the end of the Civil War, Mary (then in her 30s) had made her way to Ohio, where she found work at a Catholic mission school. Fields became close to a nun named Mother Amadeus. When Mother Amadeus was sent to Montana Territory in 1884 to help establish a mission school for Native American women, she brought along her big, loyal friend to help.

St. Peter's Mission School was built near Cascade, about 60 miles north of Helena. Fields regularly drove a mission wagon into Cascade, loading up supplies and lumber with a cigar in her mouth. There were fewer than 350 African-Americans in vast Montana Territory, and wary townspeople called her "Black Mary."

Occasionally the strapping woman brawled with one or another of the employees. Once, Fields and an antagonist angrily went for their guns. No one was hit in the exchange of gunfire, but the bishop fired Fields.

Mother Amadeus helped Fields open a restaurant in Cascade. She was a good cook, but twice she went out of business because she fed everyone regardless of their inclination to pay. Her generosity, kindness, and independence won over the people of Cascade, and she became the first woman allowed to drink in the town's

saloons. Friends helped her build a house in Cascade, and when it burned down, townspeople helped her rebuild it.

"Black Mary" became "Stagecoach Mary" by riding shotgun and working as a driver on a local stagecoach line. When a mail route was established between Cascade and the mission, Fields was appointed carrier, becoming only the second woman in history to deliver U.S. mail.

She also ran a laundry, and when a man walked away without paying his bill, Fields gently tapped him on the shoulder. As he turned around, the 70-year-old woman punched him squarely on the jaw, then announced that his bill had been paid in full.

More Cowboy Cures

Pulling baby teeth: Don't throw away the tooth, because if a dog steps on it, a dog's fang will grow in where the tooth has been pulled.

Rheumatism: Mix half a bottle of vinegar with one handful of red ants and drink.

Tapeworm: Feed patient ground glass; it will cut up the tapeworm.

Bladder trouble in a horse: Insert a match into the horse; relief will be sudden, although the patient may stampede.

Lockjaw in a horse: Drive a nail into the horse's skull. This is a sure cure—unless the nail kills the horse.

10 Cowboy Names for a Farmer

Churn Twister	Pea Picker
Fodder Forker	Plow Chaser
Fool Hoe Man	Pumpkin Piler
Hay Shaker	Stubble Jumper
Hen Wrangler	Stump Rancher

Homesteading Tall Tales

A prairie farmer was plowing his fields when the sun got so hot that the corn popped on the stalk. Thinking the popped corn to be snow, his mules froze to death.

On the Great Plains it was so cold one winter that flames would freeze. To be put out, the frozen fire had to be buried. But in the spring, the frozen fire would thaw, starting grass fires.

How to gauge wind on the Great Plains: "Hang a log chain on a post. If the wind raises the chain straight out from the post, it's a calm day. But when the end links start snapping off, expect rough weather."

Winters were so cold on one Texas panhandle ranch that the few threadbare blankets did not provide much warmth. "If I owned a ranch," proclaimed cowboy Peter Wright, "I would buy these blankets and use them as a refrigerator in the summer."

This cutting horse was so good that he could cut the baking powder out of a biscuit without breaking the crust.

This same horse was riderless on the prairie, prancing through all manner of intricate maneuvers. When his rider walked over, he saw that the horse was atop an ant bed, cutting the bull ants out of the herd and separating them from the others.

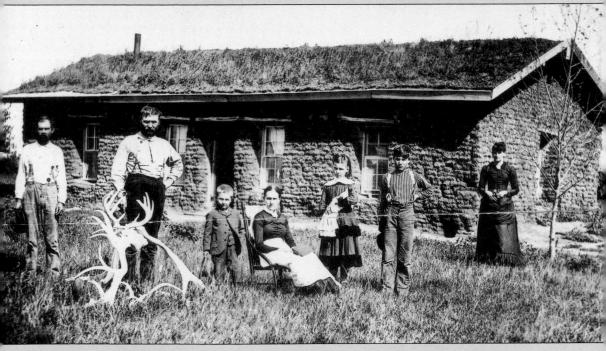

Homesteaders dressed in their Sunday best pose in front of their sod house.

BUFFALO BILL CODY

1846—1917

While still engaging in real-life adventures on the frontier, Buffalo Bill Cody began a performing career that popularized the Wild West around the world. Cody not only was a legendary frontier leader of the real West—he brought a romanticized version of his life and the Old West to captivated audiences of Easterners and Europeans via his traveling extravaganzas.

William Frederick Cody was born in a log cabin in Iowa, and in 1855 he moved with his family to the Kansas frontier. In his early teens, Will began working as a mule-riding messenger for Majors and Russell, later known as Russell, Majors & Waddell. In 1860 the company launched the famous pony express, and 14-year-old Cody was one of the riders.

During the Civil War, Cody served as a guide for Union columns on the Santa Fe Trail, and then he campaigned as a private with the 7th Kansas Volunteer Cavalry. In 1867 and 1868 he worked as a contract hunter for the Union Pacific Railroad. He killed more than 4,200 buffaloes to feed railroad workers, earning his nickname "Buffalo Bill."

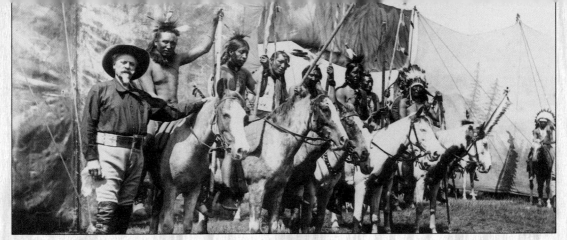

Buffalo Bill (left) stands with Native American members of his Wild West shows.

In 1868 Cody was appointed chief of scouts for the 5th Cavalry. During an 1872 exploit Cody earned the Congressional Medal of Honor. He also engaged in nearly a score of combat actions against horse warriors, most famously in 1876 when he killed a Cheyenne chieftain named Yellow Hair.

Cody was also a well-paid hunting guide, staging races and Native American exhibitions to entertain his parties. In addition, Buffalo Bill began appearing onstage in western melodramas. The idea of a Wild West show evolved, and during the early 1880s Cody went on tour with Buffalo Bill's Wild West.

Buffalo Bill's Wild West was an outdoor extravaganza featuring races, Native American chases, shooting exhibitions, rodeo events, and scenes such as Custer's Last Stand and Cody's duel with Yellow Hair. He began taking his troupe to Europe in 1887, and his fame was expanded further due to some 1,700 dime novels purporting to relate his adventures. Enormously popular, Buffalo Bill continued to perform until a short time before his death at 70.

ANNIE OAKLEY

1860—1926

"**I** was **eight years old** when I made my first shot," reminisced the legendary sharpshooter Annie Oakley, "and I still consider it one of the best shots I ever made." Spotting a squirrel perched on a fence in front of her cabin, she impulsively climbed onto a chair, dragged down a loaded rifle, rested the barrel on a porch rail, and **drilled** the small animal. Soon, the little girl was regularly putting meat in the family pot.

Phoebe Anne Moses was born in Ohio in 1860. When she was 15, local admirers **pitted her** against a traveling exhibition sharpshooter named **Frank Butler.** Annie **outshot** Butler, who persuaded her to **marry him** a year later. They formed a **vaudeville act** and then began touring with Buffalo Bill Cody's immensely popular **Wild West show** in 1885.

A natural performer and a veritable shooting machine, Oakley became one of the primary assets of Cody's Wild West. She traveled 17 years with Cody, who affectionately called her **"Little Missie."** Audiences regarded her as **America's Sweetheart,** and Chief Sitting Bull

nicknamed her **"Little Sure Shot."**

Offstage Oakley devoted herself to exquisite needlework and to reading the Bible. During World War I, Oakley and Butler toured army camps as instructors and performers. America's Sweetheart died in 1926, and Butler passed away just three weeks later.

Oakley was not a Westerner and, except for her performance tours, she never experienced the West. However, through her countless exhibitions with Buffalo Bill's Wild West and other shows, and later exposure in comic books, movies, and television, and most notably, Irving Berlin's ***Annie, Get Your Gun,*** Annie Oakley became indelibly identified with the Wild West.

WILD WEST SHOWS

America's premier entertainer, P. T. Barnum conducted a "Grand Buffalo Hunt," complete with Native American dancers in New Jersey in 1843. Exhibitions of cowboy skills began attracting spectators to Santa Fe as early as 1847. Wild Bill Hickok was hired to headline an early version of a Wild West show at Niagara Falls in 1872.

From these and other beginnings, the Wild West show gradually evolved—especially in the mind of frontier adventurer Buffalo Bill Cody. From his own experiences entertaining hunting parties and melodrama audiences, Cody grasped the possibilities of an outdoor extravaganza built around frontier events.

Careful to distinguish his spectacle from the circus, Cody kept the word "show" out of his title. Buffalo Bill's Wild West featured races, sharpshooting exhibitions, bucking broncos, exotic western animals, colorful reenactments of Custer's Last Stand and Battle of Summit Springs, and some of Cody's personal exploits.

Buffalo Bill's Wild West attracted large audiences with a swelling interest in the romance and color of the West. The show played London in 1887 for Queen Victoria's Golden Jubilee. An enormous success, Cody returned for a four-year European tour beginning in Paris in 1889. At the 1893 World's Columbian Exhibition in Chicago, Buffalo Bill's Wild West enjoyed the most prosperous season in the history of outdoor show business.

Many other Wild West shows, of varying quality, were organized. One of the most successful, Pawnee Bill's Historic Wild West, began touring in 1888, and two decades later the "Two Bills" merged their shows. Early in the 1900s, the Miller Brothers 101 Ranch put together a

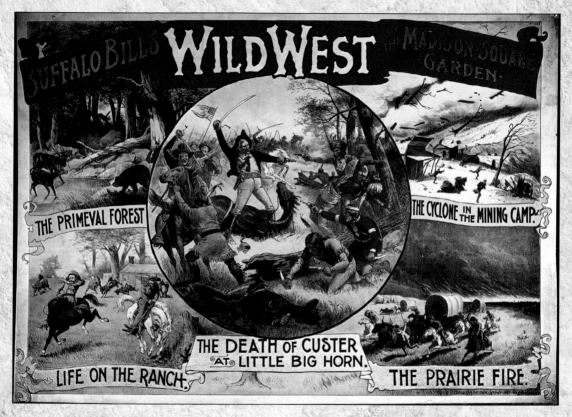

Buffalo Bill's Wild West in the Madison Square Garden.

THE PRIMEVAL FOREST

THE CYCLONE IN THE MINING CAMP.

THE DEATH OF CUSTER AT LITTLE BIG HORN.

LIFE ON THE RANCH.

THE PRAIRIE FIRE.

show featuring Bill Pickett, who invented bulldogging, also known as seizing a steer by the horns. During the 1920s and 1930s, Western movie stars headed Wild West shows. By this time, the heyday of these productions had ended, although rodeos were becoming popular. The last big show, organized by actor Tim McCoy in 1938, folded within a month. But Wild West shows had glamorized the last frontier throughout much of the world, introducing the cowboy hero and opening the way for Western novels, movies, and television shows.

Best Western Movies

Stagecoach (1939)

My Darling Clementine (1946)

She Wore a Yellow Ribbon (1949)

High Noon (1952)

Shane (1953)

The Searchers (1956)

Butch Cassidy and the Sundance Kid (1969)

Silverado (1985)

Dances With Wolves (1990)

Tombstone (1993) ▼

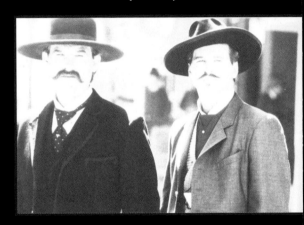

Worst Western Movie (tie)

Billy the Kid vs. Dracula (1966)

Jesse James Meets Frankenstein's Daughter (1966)

Best Western Movie Stars

Gene Autry	Tom Mix
Gary Cooper	Roy Rogers
Clint Eastwood	Randolph Scott
Dale Evans	James Stewart
William S. Hart	John Wayne
Ken Maynard	

Worst Western Movie Stars

The Three Stooges:

The Outlaws Is Coming (1965)

Notable Native Americans

Native Americans inhabited the plains, mountains, and deserts of the West. The fight for their homes was spearheaded by courageous horse warriors.

"God Almighty made [me] an Indian and did not make [me] an agency Indian, either, and [I do] not intend to be one."

—*Sitting Bull*

SACAJAWEA

1790—1812 OR 1884

In the early stages of the Lewis and Clark Expedition, at Fort Mandan on the Missouri River, an interpreter was engaged. This French-Canadian trader was named Toussaint Charbonneau. He brought along his young wife, Sacajawea, and their eight-week-old baby boy, Jean Baptiste Charbonneau, strapped to his mother's back on a cradleboard.

Sacajawea was the daughter of a Shoshone chieftain. By the time the expedition reached Shoshone country, the explorers desperately needed horses. They encountered Sacajawea's band, now headed by her older brother Cameahwait due to the recent death of their father.

Elated to show her family the baby but grief stricken over her father's death, Sacajawea nevertheless arranged for horses and supplies. She and her husband accompanied the expedition to the Pacific and part of the way back, serving for 19 months. Charbonneau was paid around $500, but Sacajawea proved to be a more valuable guide and interpreter.

Sacajawea then disappeared from history. It was reported that she died of a fever in her 20s in 1812, although there were rumors that she returned to the Shoshone and lived until 1884.

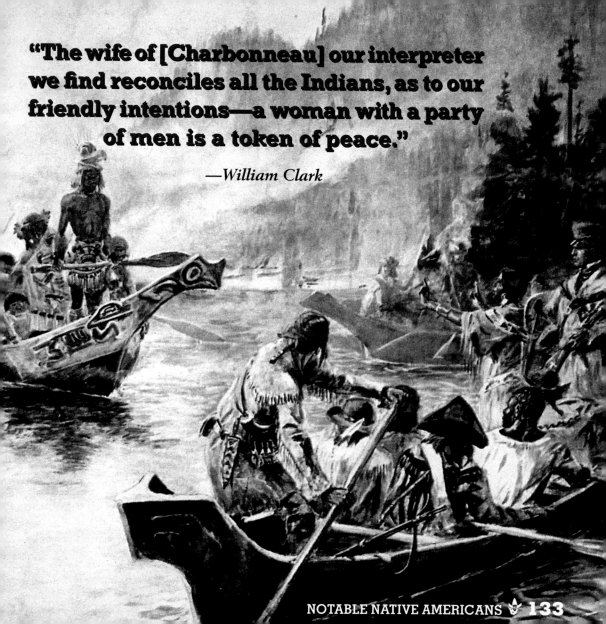

"The wife of [Charbonneau] our interpreter we find reconciles all the Indians, as to our friendly intentions—a woman with a party of men is a token of peace."

—William Clark

COCHISE
1800?—1874

Destined to become perhaps the greatest of all Apache chiefs, Cochise was born in the early 1800s in the Chiricahua Mountains. His father and grandfather were chiefs of the Central Chiricahua Apache, which made Cochise a hereditary candidate for leadership.

Like all Chiricahua boys, he was trained for war. Toughened to existence in a harsh land, Chiricahua warriors could cover 70 miles a day through rugged terrain, keeping a pebble under their tongues through waterless desert to reduce thirst. They became masters of concealment, with ambush as a constant tactic. By the 1820s Cochise was a relentless participant in raids against Mexicans, the traditional enemy of his people.

The second of Cochise's wives was the eldest daughter of Mangas Coloradas, chief of the Eastern Chiricahuas. Cochise frequently aided Mangas Coloradas in brutal raids into Mexico.

But in 1861 Cochise was falsely accused of kidnapping by American authorities and was arrested. Although Cochise managed to escape—suffering one of several wounds he took during his violent career—his brother and two

nephews were hanged. Within a couple of years Mangas Coloradas was arrested during a peace conference with the white men, then tortured, shot, scalped, and decapitated.

Cochise turned the thrust of his warfare against whites in Arizona by assaulting ranches, mines, stagecoaches, and wagon trains. Within a decade Cochise and his warriors had slain more than 4,000 people and had thwarted all efforts by the U.S. Army to subdue them.

With some persuading from a friend, Tom Jeffords, Cochise eventually agreed to peace with the American authorities, although he continued to raid below the border into Mexico.

When Cochise died in 1874, his warriors buried him in a secret place in his beloved Chiricahua Mountains. The great Apache chief had proved himself one of the most effective guerrilla leaders in the history of American warfare.

Tom Jefords (1832–1914) is shown here on his Arizona ranch. A former army scout, Jeffords launched a stagecoach line in southeastern Arizona, but he was almost driven out of business by Cochise. After 14 of his employees were killed by Apache raiders in 1867, Jeffords courageously sought out Cochise to try to negotiate on behalf of his business.

Impressed by his obvious bravery, Cochise became friends with Jeffords and called him *shikisn*, or "brother." Jeffords influenced Cochise toward peace, establishing contact between the chief and government officials. A Chiricahua reservation was organized with headquarters at Apache Pass in the Chiricahua Mountains. At the insistence of Cochise, Jeffords served as an American Indian agent.

American Indian Agents

As Native Americans moved onto reservations, the role of American Indian agents changed **dramatically.** Whereas once they had been ambassadors and negotiators, they now became **tribal administrators** of a sort. They were responsible for distributing annuities, maintaining relations between Native Americans and whites in the region, executing federal policy, and helping the American Indians adapt to reservation life. This last task—the **most difficult** of all—came in a variety of forms: farming or another stable economic industry, Christianity, or formal education, all of which were incompatible with the traditional cultures of the Plains and Southwestern Indian nations.

Few if any agents achieved long-term success in their efforts. Some were not qualified as administrators or had little if any understanding of the culture they were dealing with. Others were **shamelessly corrupt,** pocketing federal monies, selling goods meant to be used on the reservation, or parceling out American Indian lands to the highest bidders.

Already unhappy by being confined on a reservation, warriors were enraged by such treatment. Jumping the reservation, they would resume raiding, which would bring out the army—all because of an inept **American Indian agent.**

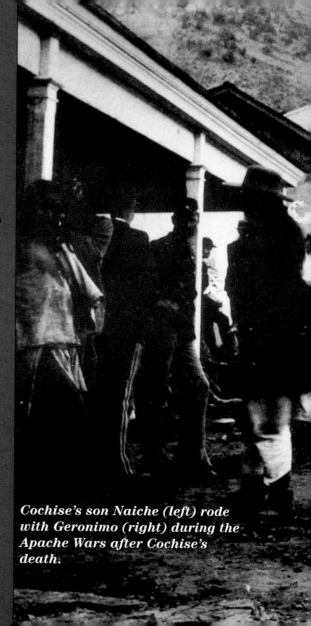

"When I was young I walked all over this country, east and west, and saw no other people than the Apaches. After many summers I walked again and found another race of people had come to take it."

—*Cochise*

Cochise's son Naiche (left) rode with Geronimo (right) during the Apache Wars after Cochise's death.

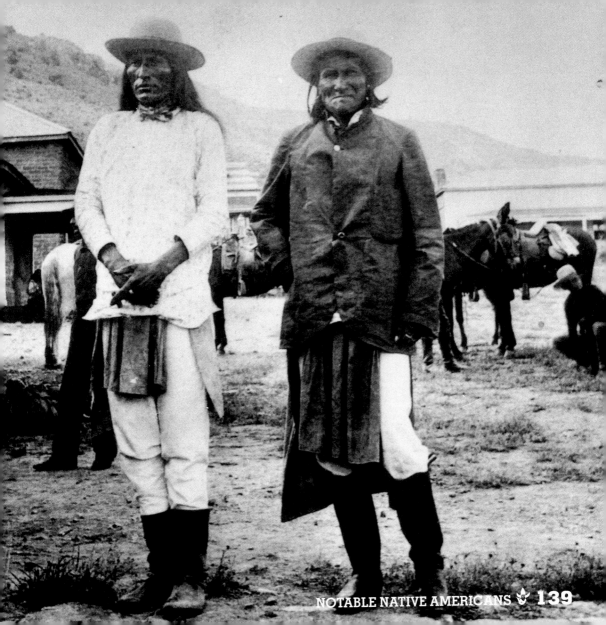

GERONIMO

1829?—1909

The Apache who one day would strike terror into the hearts of Arizona settlers was so placid as a youth that he was called *Goyahkla*—"One Who Yawns."

At 17 Goyahkla was admitted to the council of warriors. He married, and his wife soon bore him three children. But in 1858 Goyahkla's entire family was slain by Mexican soldiers while the men were absent from their camp in Chihuahua, Mexico.

Stunned by the loss, the One Who Yawns now lusted for vengeance: "My feelings toward the Mexicans did not change—I still hated them and longed for revenge. I never ceased to plan for their punishment."

Soon he led a ferocious charge against Mexicans who screamed, "Geronimo!" They were appealing for help to their patron saint, Jerome, or *Geronimo* in Spanish. Goyahkla's fellow warriors took up the cry, and the One Who Yawns became Geronimo.

Geronimo willingly followed the leadership of Mangas Coloradas and Cochise, and he also led war parties numbering as few as three braves into Mexico. Throughout the 1860s and into the 1870s he looted and killed ceaselessly. Eventually Geronimo took several wives and sired other children, but he could not abandon the warrior's life for long: "I was always glad to fight the Mexicans."

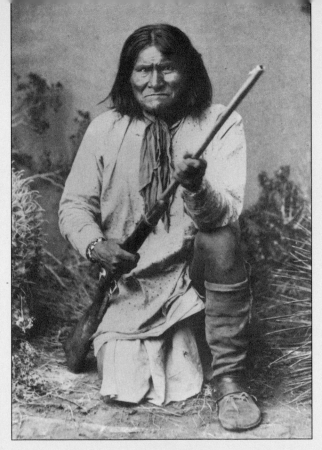

During the 1870s Geronimo moved his family onto a reservation, but occasionally he slipped away on raids, and in 1881 he led a major breakout into Mexico.

For more than two years General George Crook led a major military campaign against him. Geronimo finally agreed to meet with Crook, returning to reservation life in 1884, but the next year he again headed for Mexico with another band of diehards.

General Nelson Miles and thousands of soldiers pursued Geronimo, along with thousands of Mexicans on the other side of the border. Geronimo submitted to custody in 1886, the last Native American chief to surrender to the army.

Geronimo and his followers were shipped by train to Florida, where he remained for nearly a decade. In 1895 Geronimo was placed on the reservation at Fort Sill, Oklahoma, where he spent the last 14 years of his life. He remained a popular figure at public celebrations, proudly showing off his battle wounds and selling his autograph to fascinated admirers.

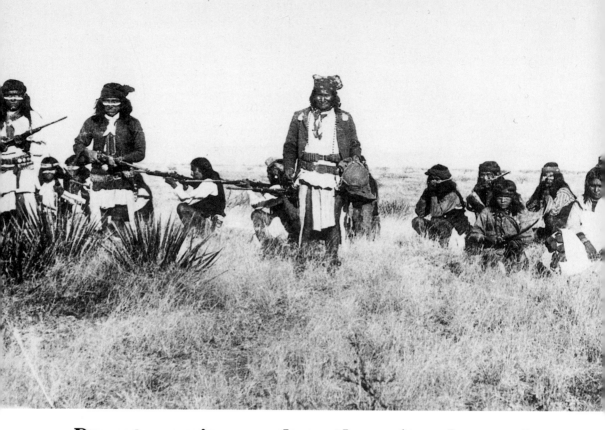

Desert warriors such as these Apaches under Geronimo (center) used hit-and-run tactics against military pursuers.

> **"We were reckless with our lives, because we felt that every man's hand was against us . . . so we gave no quarter to anyone and asked no favors."**
>
> —*Geronimo*

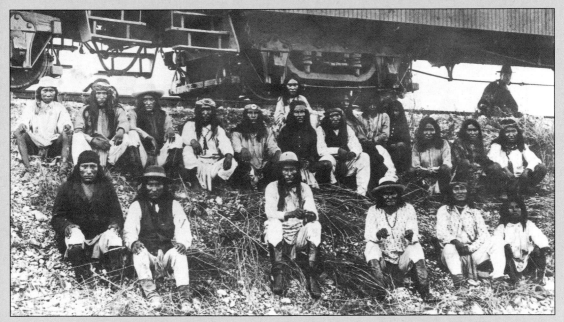

Geronimo (front row, third from right) sits with other Apache captives on their way to Florida in 1886.

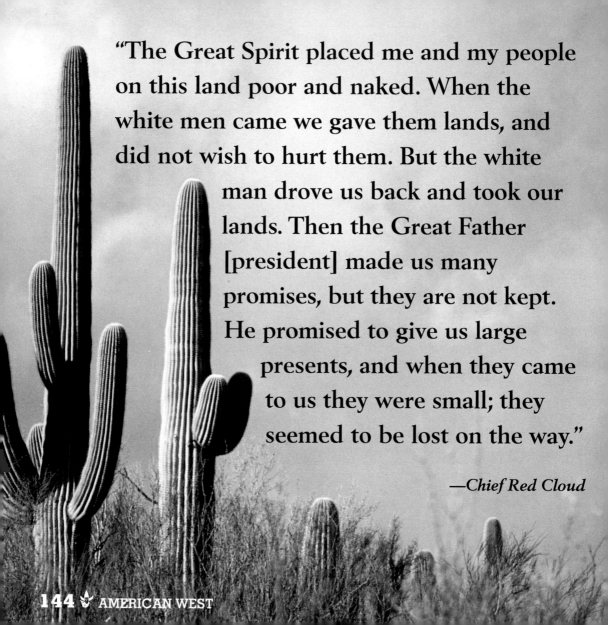

"The Great Spirit placed me and my people on this land poor and naked. When the white men came we gave them lands, and did not wish to hurt them. But the white man drove us back and took our lands. Then the Great Father [president] made us many promises, but they are not kept. He promised to give us large presents, and when they came to us they were small; they seemed to be lost on the way."

—*Chief Red Cloud*

"These Tucson people write for the papers and tell their own story. The Apaches have no one to tell their story."

—Eskiminzin, Apache leader

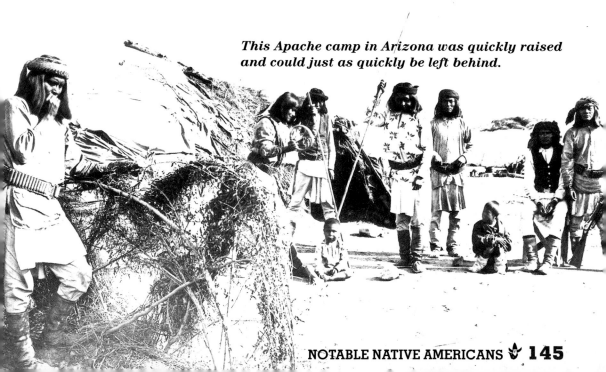

This Apache camp in Arizona was quickly raised and could just as quickly be left behind.

Nicknames for U.S. Soldiers

American Indians assigned colorful and descriptive nicknames to the European men who invaded their lands. Soldiers were known as **"Bluecoats"** and **"Long Knives,"** a reference to cavalry sabers, and members of the infantry were called **"Walk-a-Heaps."**

❧ ❧ ❧

African-American soldiers were respectfully termed **"Buffalo Soldiers,"** because the texture of their hair reminded Plains Indians of the dark, woolly fur between the horns of buffaloes, the majestic animals that provided the horse tribes with their way of life.

❧ ❧ ❧

Officers' insignia often caught the American Indian eye. A colonel was an **"Eagle Chief"** and a general was a **"Star Chief."** Aggressive Colonel Eugene Carr was called **"War Eagle,"** and General George Crook was **"Three Stars."**

❧ ❧ ❧

General Winfield S. Hancock often employed artillery and was termed **"Old Man of Thunder."**

❧ ❧ ❧

Lieutenant Charles Gatewood received the unflattering designation **"Big Nose Captain."**

❧ ❧ ❧

General O. O. Howard, who had an arm amputated during the Civil War, was called the **"One-Armed-Soldier-Chief."**

❧ ❧ ❧

Colonel John Gibbon, **"The One Who Limps,"** was shot in his good leg by a Nez Percé warrior, and became **"The One Who Limps Twice."**

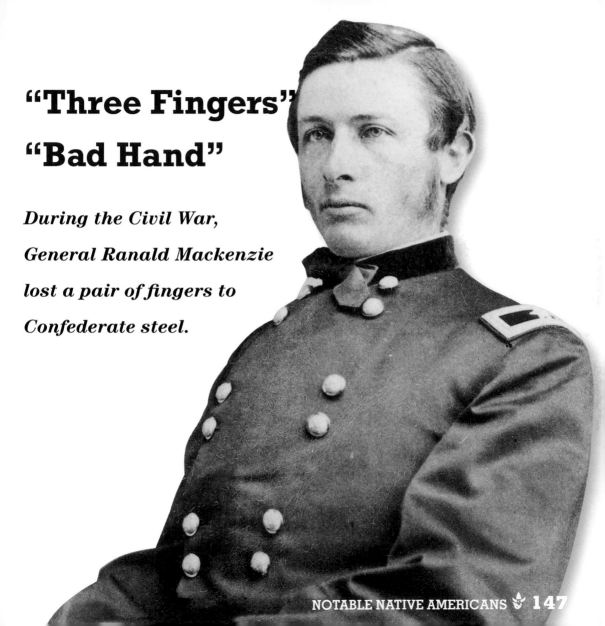

"Three Fingers" "Bad Hand"

During the Civil War, General Ranald Mackenzie lost a pair of fingers to Confederate steel.

A Courageous Comanche

In 1860 a **large 2ⁿᵈ Cavalry** patrol led by Major G. H. Thomas **jumped 13 Comanche braves** just as they were breaking camp beside the Salt Fork of the Brazos in West Texas. A running fight lasted for **three miles,** with the American Indians holding a half-mile lead.

At last an **old warrior** dropped off to cover the retreat of his comrades. When the soldiers galloped into range, the old brave **expertly** began to fire **iron-tipped dogwood shafts** from his bow. Using an interpreter, Thomas called on the Comanche to surrender, but the **brave shouted defiance** and the soldiers moved in.

The old warrior was shot **more than 20 times,** but he fired arrows into three troopers, one of whom died. When the soldiers closed in for the kill, the **dying** Comanche **wounded two more soldiers** with lance thrusts before collapsing.

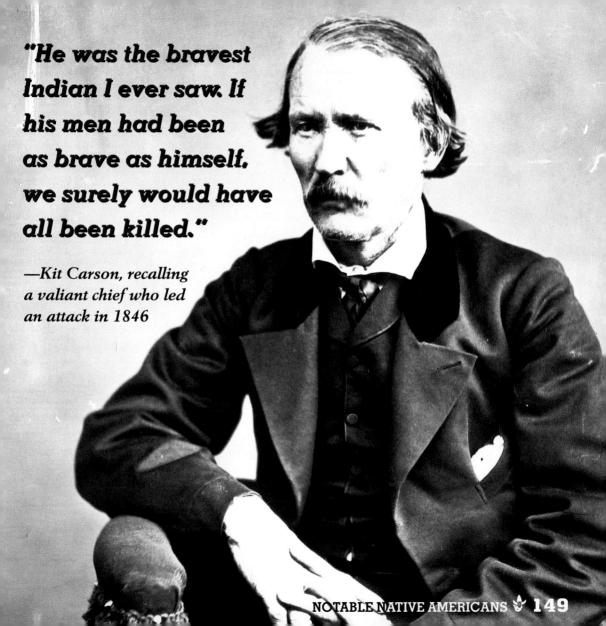

"He was the bravest Indian I ever saw. If his men had been as brave as himself, we surely would have all been killed."

—Kit Carson, recalling a valiant chief who led an attack in 1846

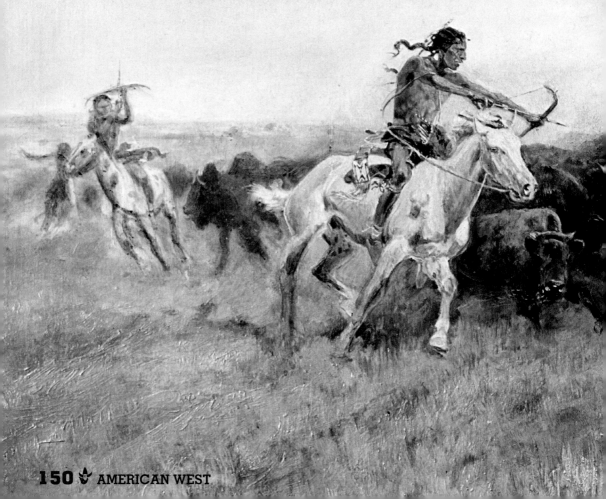

Charles Russell's "Buffalo Hunt" depicts Plains Indians in pursuit of their most important resource: buffalo. The bow and lance used by these mounted hunters doubled as lethal weapons in the hands of hard-riding warriors.

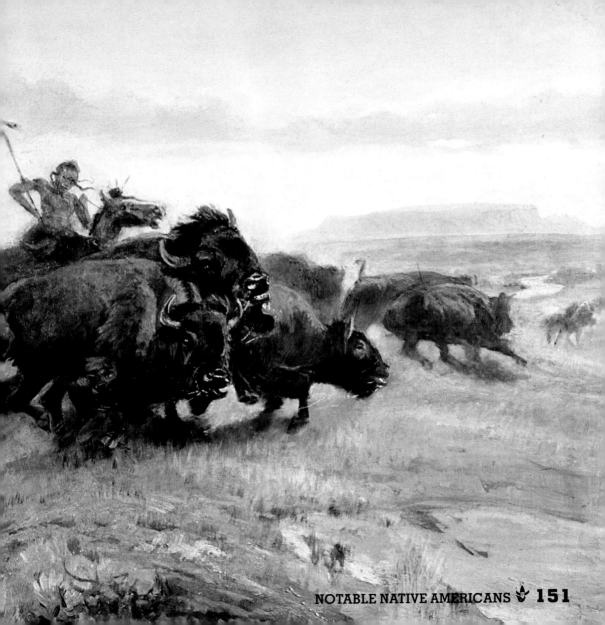

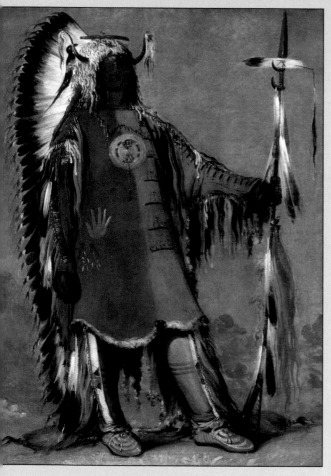

Lance

Galloping alongside a buffalo herd, a Plains tribe hunter would thrust his lance just behind his quarry's last rib, attempting to puncture the diaphragm and collapse the lungs. Often two or three thrusts were necessary, and if the beast collapsed, the lance had to be withdrawn quickly or the hunter might be pulled off the pony into the midst of a running herd of buffalo.

The hunting lance also was deadly in combat, especially if the opponent was on foot. A lance was often 16 feet in length, but it was known that "the shorter the lance, the braver the warrior."

A lance-wielding warrior also carried a round shield two or three feet across, with untanned buffalo hide stretched across both sides and paper packed in between. Warriors took books from cabins they raided to insulate their shields, which could stop arrows or musket balls.

Bows and Arrows

Plains warriors were at their most dangerous as mounted archers. Training for the hunt, a Native American boy learned to gallop beside a fleeing buffalo and guide his horse with his knees while firing arrows. The quiver, slung over the right shoulder, held 20 or more arrows. After pulling the bowstring back to his ear as a release point, the warrior quickly pulled out another arrow.

The mounted, mobile warrior thus had a repeating weapon to use against soldiers who were often armed with single-shot rifles. Accurate from 50 to 60 yards, the warrior could loose 20 arrows on the gallop while his adversary desperately reloaded. The best riders had the smoothest firing platforms. Comanches were regarded as the finest riders on the Plains, and they became the deadliest shooters.

They fashioned their three-foot bows from tough bois d'arc wood, while painstakingly making arrow shafts from ash, dogwood, or mulberry. The shafts were feathered with turkey, owl, or buzzard and were recovered whenever possible.

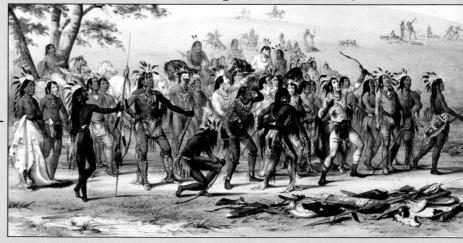

CYNTHIA ANN PARKER

1827—1870

On May 19, 1836, 150 Comanche warriors attacked Parker's Fort in east central Texas. Several settlers were killed, and nine-year-old Cynthia Ann Parker and her younger brother were taken **captive.**

Cynthia Ann grew up with the Comanche and became **content** with the Native American way of life. She was called **Nadua,** and she darkened her hair with buffalo dung to look more like her adopted people. Nadua became the wife of Peta Nocona, a Comanche leader. She gave birth to two sons, Quanah and Pecos, and a daughter, Topsannah.

On December 17, 1860, Cynthia Ann and her daughter were **"rescued"** by a group of Texas Rangers and **returned** to her biological family. The Legislature granted her a league of land and an annual pension of $100.

Although she longed to be with Peta and her two sons, her relatives would **not allow** her to leave, putting her **under guard** when she tried to escape.

Within three years Topsannah died of a childhood disease. Cynthia Ann **horrified** her relatives by mourning like a Comanche, **howling** and **slashing** her arms and breasts with a knife. Grief stricken, she refused to eat and died at her brother's home at the age of 43.

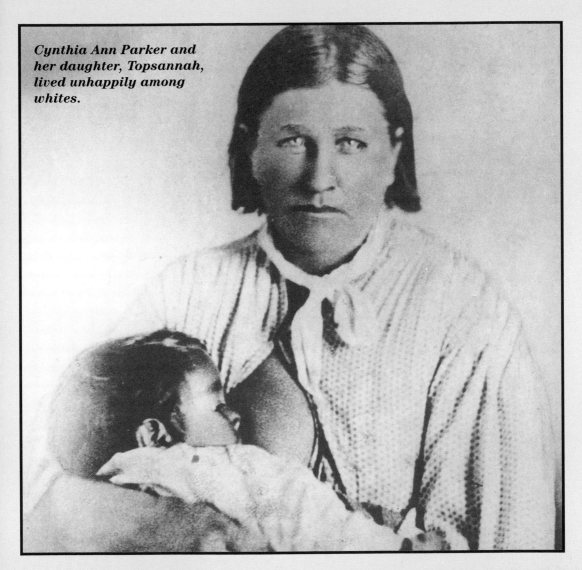

Cynthia Ann Parker and her daughter, Topsannah, lived unhappily among whites.

QUANAH PARKER

1845?—1911

Quanah ("Sweet Odor") was the son of Comanche chieftain Peta Nocona and Cynthia Ann Parker, who had been abducted by Comanche warriors as a child. Quanah was born about 1845, and later his father and mother produced another son and a daughter.

Quanah grew into a tall, strong man with bold features. He became a splendid rider and was taught to handle the traditional Comanche weapons. By the time Quanah was 15, he had slain his first victim in a raid, and soon he displayed qualities of leadership.

During the 1870s Quanah commanded his own war parties and was prominent at the Battle of Adobe Walls in the Texas panhandle in 1874. During the Red River War that followed, a massive military convergence forced Comanche and Kiowa bands onto reservations in southwestern Indian Territory. Quanah and 400 followers were the last to submit, driving 1,500 horses onto the reservation at Fort Sill in May 1875.

Texans referred to their worthy foe as Quanah Parker, emphasizing his white heritage. Still in his 30s, Quanah proved himself a skilled peacetime leader. He sold grazing rights to the 3,000,000-acre reserva-

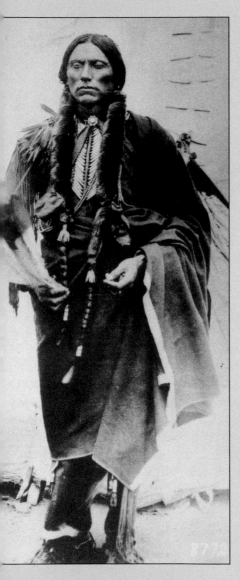

tion lands, extracting lease fees for his people from Charles Goodnight, Burk Burnett, and other cattle barons. These tough businesspeople taught him much about negotiation and subsidized his trips to Washington, D.C., where he sometimes dressed in business suits.

Burnett helped Parker erect the Comanche White House, a rambling 12-room residence near Fort Sill where he installed his vast family (he married 8 times and sired 25 children). Parker's prominence reached celebrity status, and he was in great demand for parades, including President Theodore Roosevelt's 1905 inauguration.

But during all of his interaction with whites, Parker proudly retained much of his Comanche identity, which was a key to his acceptance as tribal leader. He remained polygamous, rejected Christianity, and used peyote and mescal. And when he died of pneumonia in 1911, his demise was presided over by a Comanche medicine man.

"I have heard that you intend to settle us on a reservation near the mountains. I don't want to settle there. I love to roam over the wide prairie, and when I do it I feel free and happy, but when we settle down we grow pale and die."

—*Satanta*

SATANTA
1830?—1878

"I don't like corn," Satanta informed American Indian agent Lawrie Tatum. "It hurts my teeth."

In fact, there was very little that Satanta or fellow Kiowa warriors liked about reservation life. With no intention of digging in the dirt, they fed the seed corn they were given to their horses. Supplied with soap, they threw it away after one bite.

As an outstanding young warrior Satanta had exulted in the wild, free life of the Kiowa. Excelling in combat against other tribes and against Texans, he became a war chief while still in his 20s. Satanta also was a gifted orator and diplomat.

Satanta was in his 30s when his people agreed to live on a reservation in southwestern American Indian Territory, but he often left the reservation to lead raids. Reservation soldiers arrested him three times, and finally in 1878 he was sentenced to life in the Texas State Penitentiary in Huntsville. Unwilling to live in confinement, Satanta jumped headfirst from a second-story window and died.

BLACK KETTLE

1803?—1868

"It is not my intention or wish to fight the whites," proclaimed Cheyenne Chief Black Kettle.

No western chief was more committed to peace with whites than Black Kettle. But he was victimized by two of the most murderous tragedies ever perpetuated upon Native Americans.

Chief Black Kettle (also known as *Moke-ta-ve-to*) perceived the enormous power of whites and determined to avoid conflict for the good of his people. Whenever white soldiers or hunters arrived near his camp in southeastern Colorado, Black Kettle would move his village to avoid any possibility of hostilities. Government officials presented Black Kettle with an enormous U.S. flag, and he proudly flew it from a pole above his tepee.

On two occasions in 1864, Chief Black Kettle used his influence to restrain angry warriors from attacking parties of outnumbered soldiers. But in November 1864, while camped along Sand Creek, his village was attacked by a large force of "Colorado Volunteers" under the command of the vicious Colonel John M. Chivington.

With most of the young men absent from camp, Black Kettle's people fled, although more than 150 were killed and mutilated. After dark, he returned to locate his wife. She was still alive, despite being shot nine times. The chief carried her to safety on his back, and miraculously both survived the Sand Creek Massacre.

Government commissioners expressed regrets but informed Black Kettle that he must move to a reservation area in American Indian Territory. Other tribes rebelled,

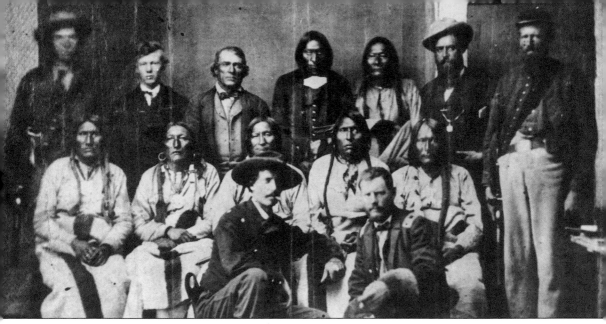

A peace conference between U.S. representatives and Kiowa, Arapaho, and Cheyenne leaders was held at Camp Weld, near Denver, in September 1864. Black Kettle is seated third from the left.

but Black Kettle kept his band off the warpath, saying, "Although wrongs have been done me I live in hopes."

But in late 1867 the U.S. Army launched a winter campaign against hostiles, and Lieutenant Colonel George Armstrong Custer led the 7th Cavalry toward Black Kettle's camp on the Washita River. The soldiers struck at dawn on November 27, 1868.

Black Kettle fired a warning shot, then leaped onto a horse and pulled his wife up behind him. But he and his wife were shot off their horse, fatally wounded. In all, more than 100 Cheyennes were brutally slain—only 11 of them warriors—and 53 women and children were captured.

Massacre at Sand Creek

"Kill all the Indians you come across."

This chilling order was delivered in 1864 to the "Colorado Volunteers" by Colonel John M. Chivington of Denver. Although Native Americans in Colorado were mostly peaceful, many whites considered them savages and coveted their lands. Playing on public opinion, Chivington organized nearly 700 volunteers and urged the killing and scalping of all Native Americans, even babies. He crudely explained, "Nits make lice!"

Chivington led his soldiers into the field and located the Cheyenne village of Chief Black Kettle on Sand Creek. Although Black Kettle always had been an advocate of peace with whites, Chivington prepared for a dawn attack on November 29, 1864.

Black Kettle's tepee was in the middle of the camp, and he raised a large U.S. flag, then a white flag of surrender. The warriors were away on a hunt, leaving about 600 women, children, and old men in camp. As his people gathered nervously around him, Black Kettle assured them they were safe.

Robert Lindneaux's 1936 painting depicts the Sand Creek tragedy.

Elderly Chief White Antelope walked toward the whites, holding up his hands and shouting, "Stop! Stop!" But White Antelope was gunned down, and the volunteers, many of whom had been drinking heavily during their night march, opened a general fire.

Black Kettle led a retreat up a ravine. Nine whites were killed and 38 were wounded, mostly by their own fire. Chivington's command killed about 150 women, children, and elderly men, then indulged in an orgy of mutilation.

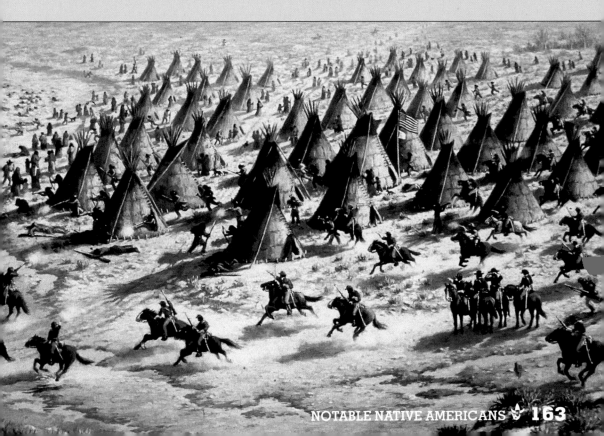

Winner of seven Academy Awards, including Best Picture, Dances With Wolves *depicted life among the Sioux with warmth and colorful detail.*

Top Five
Native American Movies

Broken Arrow (1950)

James Stewart stars as American Indian agent Tom Jeffords. **Jeff Chandler** plays Cochise. This movie was a turning point in screen portrayals of Native Americans.

Apache (1954)

Burt Lancaster plays a real-life Apache rebel with **Jean Peters** as his wife.

Cheyenne Autumn (1964)

John Ford directed this story of the Cheyenne ordeal. **Gilbert Roland, Ricardo Montalban,** and **Sal Mineo** star as memorable Cheyennes.

Ulzana's Raid (1972)

Burt Lancaster plays a cavalry scout, and **Jorge Luke** is superb as an Apache scout for the army. **Joaquin Martinez** stars as Apache war leader Ulzana.

Dances With Wolves (1990)

Kevin Costner *(opposite)* stars as a cavalry officer who befriends a Sioux tribe while **Graham Greene** plays a thoughtful, gracious Sioux leader. This movie climaxed the trend of humanizing Native Americans begun by *Broken Arrow* 40 years earlier.

CHIEF JOSEPH

1840—1904

"**I** am tired; my heart is sick and sad. From where the sun now stands, I will fight no more forever."

Chief Joseph pronounced these oft-quoted words in 1877. This was during the climax of an epic campaign in which his Nez Percé battled the U.S. Army with such skill and unity that they won the admiration of everyone familiar with the history of the West.

The Nez Percé were peaceful Native Americans who inhabited magnificent territory in the Northwest that, in time, became coveted by whites. During negotiations the principled eloquence of a tall young chieftain called Joseph attracted the notice of army officers, government officials, and the nation's press.

The impressive orator was born in 1840 and named *Hin-mah-too-yah-lat-kekt*, which meant "Thunder Rolling Down from the Mountains." He was raised in the beautiful Wallowa Mountains, and at the age of 31 succeeded his father, a distinguished leader, as head of the Wallowa band. Despite Joseph's eloquent diplomacy, the Nez Percé rebelled against white encroachments in 1877.

Expertly dueling army contingents along the way, 800 Nez Percé men, women, and children trekked nearly 1,700 miles before being cut off by General Nelson Miles just 40 miles from Canada. Joseph's brother, the Nez Percé war leader, had been killed, along with the majority of the warriors. Joseph surrendered 431 Nez Percé, including only 79 men.

Chief Joseph had not been a combat leader, but abashed army officers portrayed him as a military genius. Through ensuing years Joseph's articulate pleas were ignored and he was never permitted to return to his beloved Wallowa Mountains. But by the time of his death the public had come to regard him as the personification of the noble "red man."

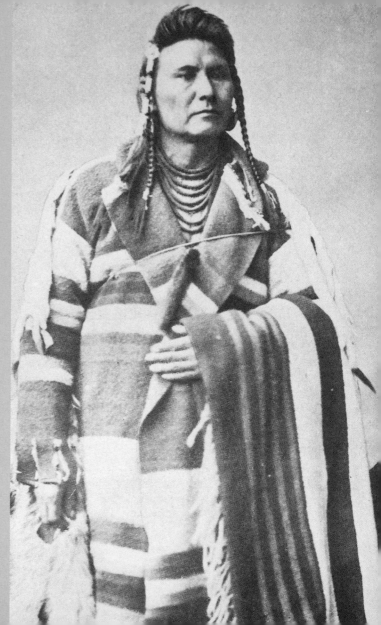

"I have asked some of the **GREAT WHITE CHIEFS** where they get their **AUTHORITY** to say to the Indian that he shall **STAY IN ONE PLACE**.... They cannot tell me."

—*Chief Joseph*

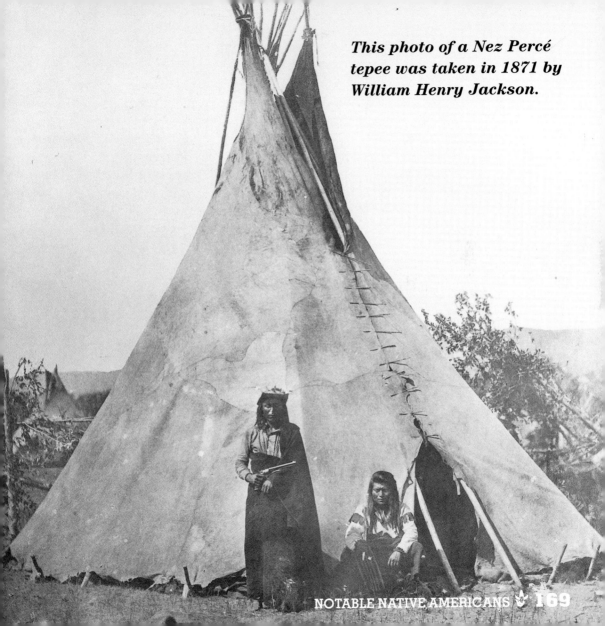

This photo of a Nez Percé tepee was taken in 1871 by William Henry Jackson.

RED CLOUD

1822—1909

Red Cloud spent the first half of his long life as a free Oglala Sioux, a gifted warrior and hunter who reveled in the exhilarating life of the horse Indians of the northern Plains.

He claimed his first scalp when he was 16. During a raid against the Crows he boldly killed the enemy chief, and on another raid he killed four Pawnee braves. By the 1860s Red Cloud was battling white soldiers.

Widely acknowledged as the best war leader of the Oglala, he soon commenced a bloody

and successful campaign known as Red Cloud's War. In the early 1860s the Bozeman Trail to Montana's gold fields cut through some of the richest hunting grounds of the Sioux and Cheyenne. Red Cloud and other leaders harassed travelers on the trail, and in 1865 the U.S. government began erecting a series of protective forts.

Red Cloud extended his guerrilla war from white travelers to the soldiers. In 1866 the warriors annihilated an 80-person column from Fort Phil Kearny, and Red Cloud continued to send his warriors against civilians and soldiers at every opportunity. Finally the War Department relented. In 1868 the Bozeman Trail forts were abandoned, and the trail was closed. Red Cloud had engineered the only successful campaign waged by Native Americans against the U.S. Army.

But Red Cloud's triumph proved hollow as the Sioux culture was threatened by the unending encroachment of whites and the accelerating disappearance of the buffalo herds. In 1870 Red Cloud traveled by train to Washington, D.C., to appeal to another great warrior, President Ulysses S. Grant. This trip, and six other visits to the capital, made him realize the extent of his enemy's size and power. Although he stated his intention to fight to the death rather than submit, his responsibilities as a leader impelled him to bring his people onto reservations.

For the last four decades of his life, Red Cloud was subjected to maddening injustice from whites and to endless criticism from discontented Sioux. His death in 1909 probably brought welcome relief to the old chief.

Peace Council, 1868

In this Matthew Brady photograph,
Red Cloud is shown at the far left.

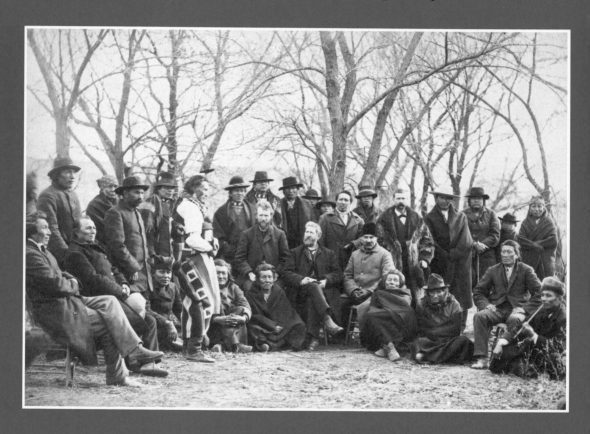

Chief Red Cloud is shown with his children in 1909.

"Whose voice was first sounded on this land? The voice of the red people who had but bows and arrows."

—*Red Cloud*

TOOLS FOR BATTLE

Before Native Americans traded for firearms, they relied on these weapons as their primary tools for everyday life.

This tomahawk was used in the Blackhawk Wars during the 1830s.

Apache war clubs had a stone head and shaft wrapped in shrunken rawhide. The stone head is hinged to deliver more force.

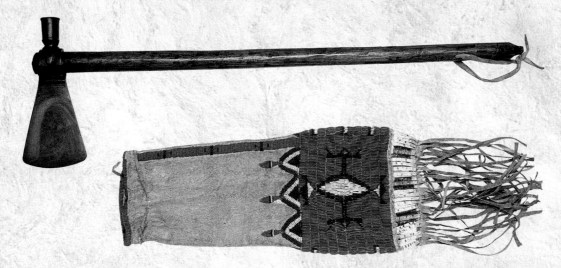

This utilitarian tomahawk is decorated with burn markings and was probably picked up after the Massacre of Knee Creek. Bottom: This deerskin pouch was made to contain smoking tobacco and a pipe. It's decorated with intricate beading and flattened porcupine quills.

This American Indian pipe was carved from red catlinite stone found in the stone quarries of southwestern Minnesota.

SITTING BULL
1831?–1890

Sitting Bull was devoutly religious with the soul of a prophet, but he also possessed the ferocious instincts of a warrior and the leadership gifts of a general. He was just 14 when he counted his first coup over a Crow brave—the first of 63 he would accumulate during his career. In an 1856 battle with Crows, Sitting Bull was shot in the foot by a chief. But Sitting Bull shot the chief off his horse, then limped forward to finish him off with his knife.

This superb war chief began a long struggle with whites in 1863. When the War Department ordered all Sioux to report to the reservation by the end of 1876, Sitting Bull sent a message to the Sioux, Arapaho, and Cheyenne: "We must stand together, or they will kill us separately."

More than 10,000 men, women, and children from various tribes responded, and Sitting Bull was chosen war leader of the combined force. Soon scouts brought word that three army columns were on the march from different directions. "These soldiers have come shooting; they want war," stated a resolute Sitting Bull. "All right, we'll give it to them."

On June 17, 1876, General George Crook's column of 1,300 soldiers was attacked by a war party of similar size. The ensuing six-hour Battle of the

SIOUX

Rosebud was the largest in scale during the long history of warfare between whites and Native Americans. Crook pulled back in the face of ferocious resistance.

Eight days later, George Armstrong Custer led his 7th Cavalry against the vast encampment along the Little Bighorn River. Custer and 265 of his soldiers were slain, but Sitting Bull's great triumph proved fleeting. Unrelenting military pressure and the rapid extermination of the buffalo drove most of the Sioux onto the reservation.

Sitting Bull and 400 followers fought their way to Canada, but his band dwindled, and he reluctantly surrendered to U.S. authorities in 1881. Lionized by the public as a Wild West legend, he toured with Buffalo Bill's troupe for several months in 1885. But at Wounded Knee in 1890, Sitting Bull was shot to death at his reservation cabin.

"I hate all white people. You are **thieves** and **liars.** You have taken away our land and made us outcasts."

—Sitting Bull

An early leadership role required Sitting Bull to provide his people with buffalo. To supply the tribe's needs, Sitting Bull and his hunters had to **kill at least 30,000 buffalo** each year.

"Indians! There **are no Indians left** but me!"

—Sitting Bull to a newspaper reporter

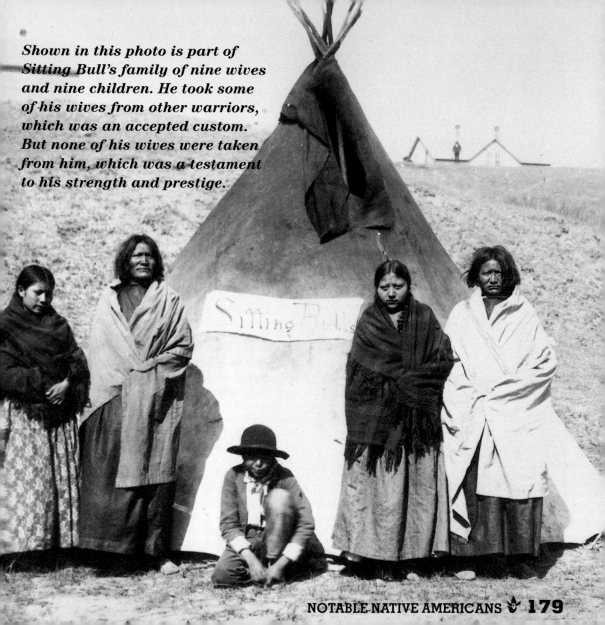

Shown in this photo is part of Sitting Bull's family of nine wives and nine children. He took some of his wives from other warriors, which was an accepted custom. But none of his wives were taken from him, which was a testament to his strength and prestige.

Sitting Bull's

Crazy Horse Monument

The monument is located 17 miles southwest of Mount Rushmore.

"My lands are where my dead lie buried."

—*Crazy Horse*

CRAZY HORSE

1841?—1877

Daring, aggressive, and courageous, Crazy Horse rode as a Sioux warrior for more than two decades, counting hundreds of coups. He led his warriors with precise skill against Crow, Shoshone, and white soldiers.

In 1866 Crazy Horse and a party of 10 decoys lured Brevet Lieutenant Colonel William J. Fetterman and 80 soldiers into an ambush. Until the Battle of the Little Bighorn, the Fetterman Massacre was the army's worst defeat in the West.

A decade later at the Battle of the Rosebud, Crazy Horse commanded more than 1,200 warriors against General George Crook and his 1,300 soldiers. Crook withdrew after six hours. Eight days later, Crazy Horse provided inspired leadership at the Battle of the Little Bighorn.

Despite these victories, the buffalo were virtually exterminated by hide hunters, and in 1877 Crazy Horse was forced to bring his starving people onto the reservation at Fort Robinson, Nebraska. Soon it was decided by General George Crook to confine the great war leader to the guardhouse. When Crazy Horse went for a knife he was bayoneted fatally, and his parents buried the heart and bones of their 36-year-old son in a secret place.

The Little Bighorn

The West's most famous battle pitted glory-seeking George Armstrong Custer and his 7th Cavalry against 3,000 warriors under the leadership of Sioux Chief Sitting Bull.

On June 25, 1876, Custer found a vast encampment of 10,000 Native Americans on the Little Bighorn River. Having already split his command into four units, Custer ordered Major Marcus Reno to launch an immediate attack with 112 soldiers. Custer meanwhile would ride with five companies, totaling 215 troopers, and strike near the rear of the camp.

Faced with overwhelming numbers, Reno was forced to retreat until the warriors broke off to face Custer's greater threat. While Reno's soldiers scrambled to higher ground and linked up with the other two detachments, Custer suddenly was forced back by a swelling horde of warriors. Within an hour all 216 soldiers lay dead, scalped and mutilated.

For two days Reno held out, losing a total of 50 soldiers before a relief column arrived. The Native Americans suffered an estimated three dozen to 300 casualties, while inflicting the worst defeat ever suffered by the U.S. Army in the West.

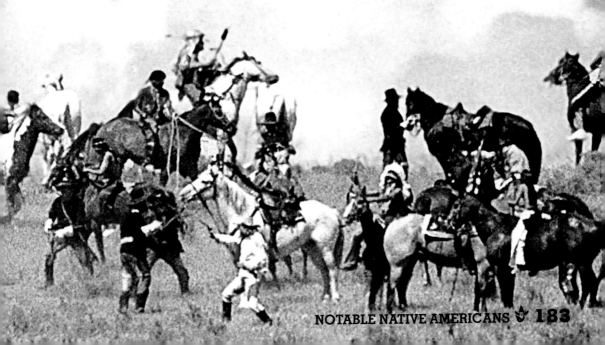

"This war did not spring up here in our land. It was brought upon us by the children of the Great Father who came to take our land from us without price, and who, in our land, do a great many evil things."

—*Spotted Tail Brule, Sioux Chief*

Hard Backsides Custer

American Indians dubbed George Armstrong Custer "Long Hair" because he often let his long locks flow to the shoulders, in the flamboyant style of people living on the Plains. Native Americans also called him "Hard Backsides," since he chased them relentlessly without ever leaving the saddle. Hard Backsides Custer chased the American Indians, of course, until they caught him at the Little Bighorn.

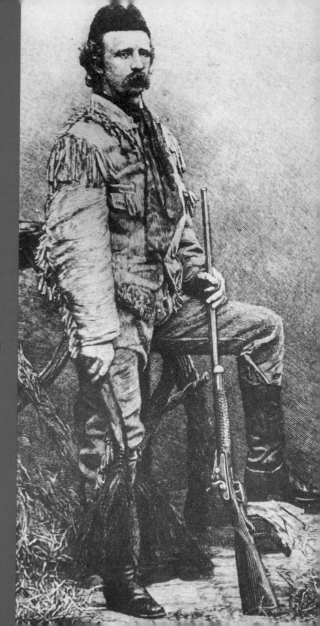

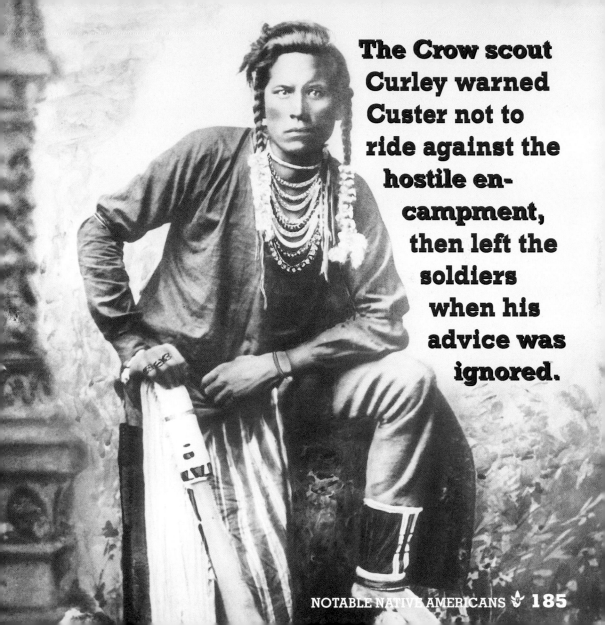

The Crow scout Curley warned Custer not to ride against the hostile en-campment, then left the soldiers when his advice was ignored.

White Bull

The most outstanding warrior at the Little Bighorn was White Bull, chief of the Miniconjou Sioux. During the fight with George Armstrong Custer, he counted seven coups, six of which were firsts. He also killed two soldiers, captured two guns and a dozen horses, took a bullet in the ankle, and had his pony shot from under him. Covered in glory, White Bull presented two pairs of confiscated soldier breeches to his father, Makes Room, who proudly composed a song in honor of his son.

During Major Marcus Reno's retreat, another brave Sioux, One Bull, killed three soldiers with a stone-headed war club. His final victim fell from the saddle into the river, whereupon One Bull started to ride down other fleeing troopers. But Sitting Bull, his uncle, shouted out to him to let them escape, so that they could

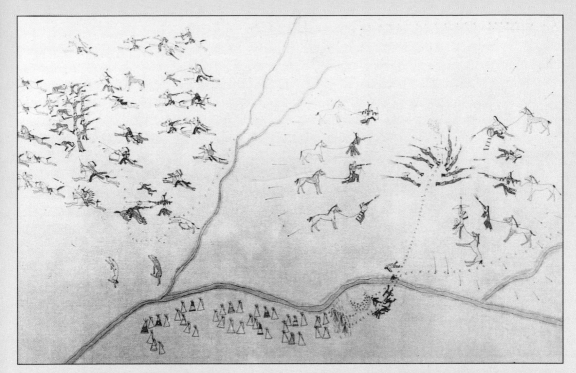

This is a Native American pictograph of the Battle of the Little Bighorn.

tell the truth about the fight. As One Bull reluctantly turned back, Sitting Bull was alarmed by the sight of blood all over his nephew, but the young warrior laughed because the blood was not his.

Sioux police officers were sent to **arrest** Sitting Bull in December 1890. When they surrounded his reservation cabin, the chief's followers **swarmed** to his support. Fighting erupted, and among a **dozen casualties was Sitting Bull,** shot through the torso and head.

Shown below are the Sioux police guard sent to arrest Sitting Bull in December 1890.

Wounded Knee

On **December 15, 1890,** Sitting Bull was slain in an incident that also cost the lives of five Ghost Dancers and six Sioux police officers. Chief Big Foot, a friend of Sitting Bull, and 350 Sioux followers tried to escape their reservation. Before dawn on December 29, the soldiers of the 7th Cavalry, still bitter over their 1876 defeat at the Little Bighorn, surrounded Big Foot's camp at Wounded Knee Creek.

When the troopers awakened the camp and began disarming the braves, shooting broke out. Bitter hand-to-hand fighting ensued, and rapid-firing Hotchkiss guns opened up. The Sioux suffered 146 dead, including 44 women and 18 children, along with 51 wounded. Cross fire from the soldiers inflicted some of their own casualties, which totaled 25 dead and 39 wounded.

Incensed at what he considered a military blunder, General Nelson Miles closed in on some 4,000 rebellious Native Americans with 3,500 troopers. Masterfully utilizing personal diplomacy as well as gradual military pressure, Miles averted further bloodshed and secured a **general surrender** on January 15, 1891. The Wounded Knee Massacre ended the long Native American wars.

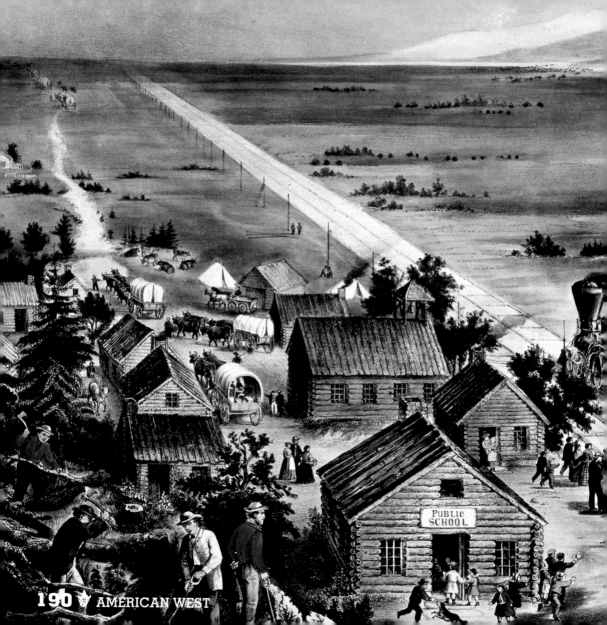

PUBLIC
SCHOOL

The West Takes Shape

Explorers and mountain men, colonizers and settlers relentlessly spread the American civilization into the West. Their exploits were recorded by painters and photographers, novelists and actors.

"**Money was as plenty as dust; every individual considered himself wealthy, and a melancholy countenance was nowhere to be seen.**"

—*Mark Twain*

MERIWETHER LEWIS AND WILLIAM CLARK

The Lewis and Clark Expedition was an extraordinary adventure, an epic in the annals of world exploration. Meriwether Lewis (1774–1809) and William Clark (1770–1838) were co-commanders of the Corps of Discovery, 31 people who spent 28 months overcoming extreme hardships and dangers during an 8,000-mile trek that opened the unknown Northwest to the United States.

Lewis and Clark were born four years apart on their families' Virginia plantations. Both boys grew up learning how to ride and shoot and became experts outdoors. Lewis and Clark both obtained infantry commissions in the U.S. Army, and as a result, the young officers developed a close friendship.

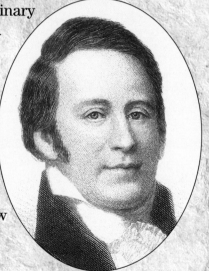

William Clark

Early in 1801 President-elect Thomas Jefferson asked Captain Lewis to serve as his private secretary. As Secretary of State during the 1790s, Jeffer-

son had tried to organize an expedition to the Pacific Coast. As president he achieved the Louisiana Purchase in 1803, paying Napoleon Bonaparte about $15,000,000 for 828,000 square miles—$34 per acre!—west of the Mississippi. This "Empire for Liberty" doubled the size of the United States, and Congress authorized funding for the Corps of Discovery to explore the enormous new territory.

President Jefferson assigned his capable secretary to lead the expedition, but Captain Lewis requested the assistance of Clark. With a strong scientific background, Lewis would ignore fatigue during the expedition to spend hours each night

Meriwether Lewis

recording the day's events and information. Clark, a competent drafter, would produce images of flora and fauna, and his expertise with the river placed him in charge of water transportation. Lewis and Clark inspired loyalty and response from their brigade by repeated displays of courage, endurance, decisiveness, and other intangible qualities of leadership.

Lewis and Clark led the Corps of Discovery into an unknown wilderness in 1804. They emerged in 1806 with maps, specimens, and drawings and descriptions of animals and plants, geography and weather, and friendly and unfriendly Native Americans. Congress gratefully provided pay bonuses and land allotments, and Lewis and Clark became national celebrities.

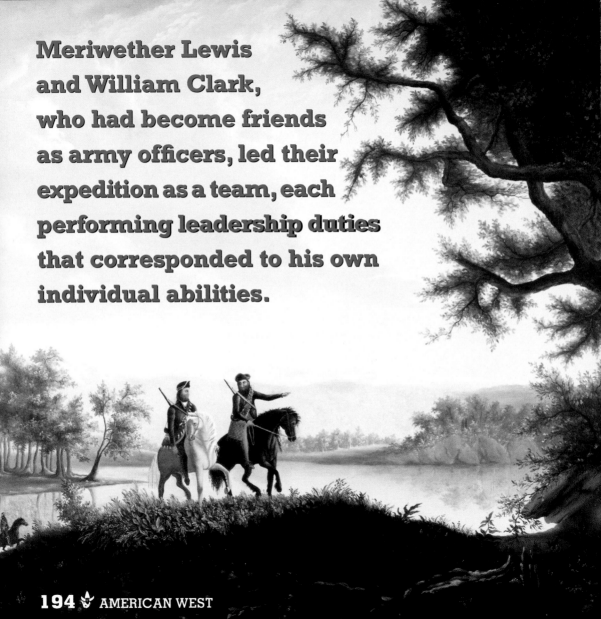

Meriwether Lewis and William Clark, who had become friends as army officers, led their expedition as a team, each performing leadership duties that corresponded to his own individual abilities.

Shown here is Charles Russell's painting of Meriwether Lewis and William Clark meeting with Shoshones near the Rockies. At this point, the explorers were in desperate need of supplies and horses, and they were unsure whether the Shoshones would aid or attack them. Fortunately the leader of the band was Sacajawea's brother, whom she had not seen since childhood. Because she had joined Lewis and Clark, the expedition was saved.

James P. Beckwourth

1800?—1866

A black mountain man, Jim Beckwourth found acceptance by Crows, who were generally friendly to trappers.

"I therefore resolved to abide with them, to do my best in their company, and in assisting them to subdue their enemies."

Jim was born in Virginia, the son of a European plantation overseer and a slave. His father moved the family to St. Louis so that his children could enjoy better opportunities, and Jim was apprenticed to a blacksmith.

In 1824 Beckwourth signed on as a blacksmith and servant with a trading expedition to the Rocky Mountains. He stayed in the mountains as a fur trapper.

For several years Beckwourth lived among the Crows, helping to fight their traditional enemies and leading their efforts to trade with whites. He married at least two Crow women and fathered several children.

Beckwourth was in California during the gold rush era, then moved to Denver. He served as a guide to Colonel John M. Chivington during the Sand Creek Massacre.

Visiting a Crow village in Montana Territory, Beckwourth died in 1866. He was laid to rest in Crow fashion on a tree platform.

The Wagon Train

The first great migration of settlers into the far West occurred during the 1840s, when "Oregon fever" sent caravans of prairie schooners streaming northwest along the Oregon Trail. The famous route zigzagged across the West for 2,000 miles. With good fortune, a wagon train would make the trek in about four and a half months.

Wagon trains generally departed on this long journey during May, when prairie grass became luxuriant. By persistent travel, the voyagers crossed the mountains before snow closed the passes. A late start, a slow pace, or delays of any kind could prove disastrous. During a good day on the trail, a wagon train might cover 20 miles. But the average was far less because too many days were spent crossing rivers or mountains. If the train pushed too hard, draft animals broke down.

Because horses were expensive, draft animals were mules or oxen. At least two teams of mules or two yoke of oxen were needed to haul a wagon. Mules made the trip more rapidly. But oxen did not cost as much as mules, did not run away at night, could pull heavier loads, and, if necessary, provided better meat than mules.

A solitary wagon was vulnerable to attack by war parties, which was the primary reason to travel in trains. The democratic political traditions of American pioneers facilitated the organization of a wagon train, as emigrants readily elected a captain and various other officers. Wagons were circled at night into a protective ring, and sentinels were posted, so that warriors almost never

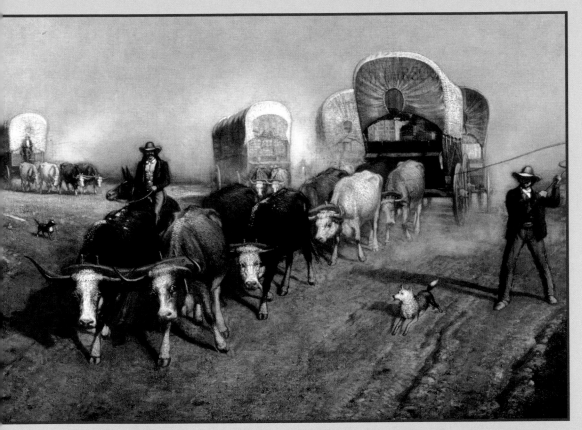

Like the sailing ships that brought the pilgrims to America, these "Ships of the Plains," as painted by Samuel Colman, brought settlers West.

attacked a wagon train. But disease, hardship, and accidents exacted a sad toll. Throughout the years, hundreds of thousands of emigrants pushed westward across the Oregon Trail, and at least 20,000 of them died along the way.

ZEBULON PIKE

1779—1813

Almost overlooked in the wake of the Lewis and Clark adventure is the probe by Captain Zebulon Montgomery Pike into the unexplored southwestern reaches of the Louisiana Purchase.

Pike had been in the army since the age of 15, when he joined his father's command as a cadet. He served at several frontier outposts, married the daughter of a general, and, in 1805, he led an exploration to the headwaters of the Mississippi River.

The next year Pike left St. Louis, taking about 20 comrades toward the Rockies. The party erected a stockade at present-day Pueblo, Colorado, and then partially ascended the peak that now bears Pike's name. After exploring the Royal Gorge early in 1807, Pike and his group were arrested for crossing

into Spanish territory. An escort marched them to Santa Fe for questioning, and later across Texas—inadvertently providing more data—before depositing the Americans in Louisiana.

Pike was promoted to major in 1808, then to brigadier general during the War of 1812. General Pike was killed in action at the age of 34.

Despite snow and frigid temperatures, Pike and his comrades pressed through the Rocky Mountains during the winter of 1806–07. The mountain Pikes Peak in Colorado was named after him.

Jedediah Smith

1798–1831

In the spring of 1822 Jed Smith, a **tall, serious, and devoutly religious** adventurer, enlisted as a hunter with a pioneering fur trading expedition in St. Louis. For the next decade Smith would pack his **Bible and Hawken rifle** and range across the West, journeying more than 16,000 miles. His travels were classics of adventure and exploration, adding greatly to American geographical knowledge.

In 1823 Smith was **mauled** by a grizzly. His scalp, left ear, and eyebrow were **horribly ripped** then **crudely stitched.** Smith thereafter wore his hair long to conceal the resulting scars. He escaped another bear by diving into a creek, and yet another time Smith was attacked while mounted. The bear seized his horse by the tail, but the terrified mount bolted powerfully, dragging the beast 40 or 50 yards before breaking free.

He had other close calls with **hostile war parties,** but Smith distinguished himself in combat and established a reputation for awesome courage. **A superb trapper,** Smith personally took **668 beaver**

pelts during the winter of 1824–25, a record for an individual during a single season.

Smith led several large trapping expeditions into the mountains, but at the **rendezvous of 1830** he and two partners sold out to the newly organized Rocky Mountain Fur Company. His profits were large, so he bought a home and two house slaves in St. Louis. But the **Santa Fe Trail,** which Smith had never traversed, promised adventure and profit. The 32-year-old Smith set out as the head of a trading party in the spring of 1831.

A month later he rode alone in search of a water hole. Smith located water—and a concealed Comanche war party. He managed to kill the chief, but the warriors quickly overwhelmed him. The body of Jedediah Strong Smith was **never found.**

The Rendezvous *"The Rendezvous is one continued scene of drunkenness, gambling, and brawling and fighting, as long as the money and the credit of the trappers last."*

George Ruxton wrote that in his 1847 book, *Adventures in Mexico and the Rocky Mountains.* He described the wild, rowdy atmosphere of the carnivallike annual gatherings that highlighted the western fur trade. For a decade and a half, fur trappers and St. Louis traders spent a month each summer buying and selling—and engaging in riotous debauchery.

A caravan from St. Louis first rendezvoused with trappers at Wyoming's Green River in the summer of 1825. The caravan brought supplies, trade goods, and whiskey, while skilled trappers arrived with 300 to 400 beaver pelts. For his furs, a mountain man might be paid $1,000 to $2,000 during an era when a carpenter might earn $10 per week.

The annual rendezvous immediately became the most important business and social occasion of the fur trade. For a few weeks each year, mountain men enjoyed drinking, gambling, womanizing, wrestling, horse races, and shooting matches. The fur trade declined during the 1830s, and the last rendezvous was held in 1840, but a standard of frontier sprees had been set that would never be equaled.

Hawken Rifle
The most popular rifle among mountain men was the rifle made in St. Louis by Jacob and Samuel Hawken. The 12-pound Hawken had a shorter but heavier barrel than the Kentucky long rifle that had won

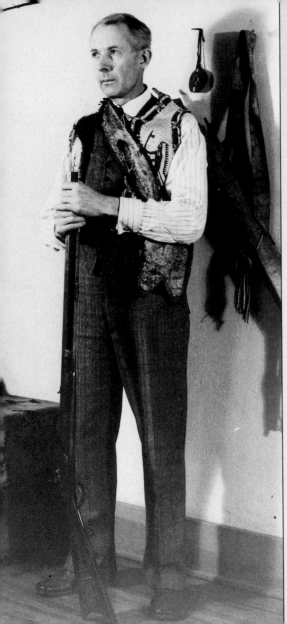

over those in the Allegheny wilderness. When new and in good condition, the Hawken was deadly accurate at 100 yards. For a particularly skilled shooter, it was effective at 300 yards, and a lucky shot could kill beyond that range. A Hawken rifle cost about $25 in St. Louis during the 1830s, but the price skyrocketed out in the mountain wilderness. Long after percussion caps displaced flintlock ignition in the East, many mountain men disdained the newfangled technology. The caps were more reliable in wet weather, but if a mountain man lost his manufactured caps, he would have no way of firing his weapon. With a Hawken, however, he could always splash fresh powder in the pan or replace a chipped flint.

Dr. A. H. Jones of Denver holds a Hawken rifle in 1932. Made in St. Louis by Jacob and Samuel Hawken, this gun was the firearm most favored by mountain men.

JIM BRIDGER

1804—1881

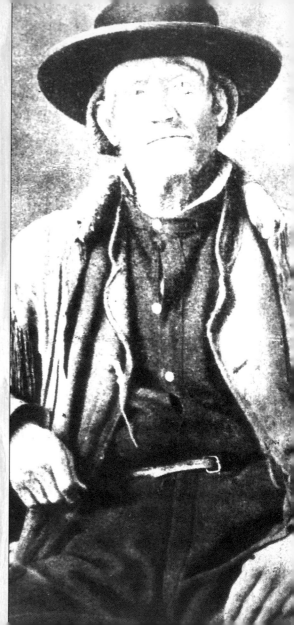

> "Out thar in Yellowstone, thar's a river that flows so fast it gets hot on the bottom."

Jim Bridger sometimes was regarded as a **liar** when he described western wonders he had seen, but he didn't have to tell tall tales. His career in the West commenced the week of his 18th birthday. Bridger's apprenticeship with a St. Louis blacksmith ended when he turned 18, the same week that General William Ashley asked for "Enterprising Young Men" to enlist in a hunting and

trapping expedition up the Missouri River. In April 1822 Bridger boarded a keelboat and commenced his first great adventure.

Bridger mastered the skills of a trapper and developed the instincts of an explorer, which he displayed in 1824 by **discovering the Great Salt Lake.** Throughout his career he maintained an uncanny ability to maneuver through his beloved Rocky Mountains. The Bridger Mountains, Bridger Creek, Bridger Crossing, Bridger's Ferry, Bridger Flat, Bridger Pass, Bridger's Road, and the Bridger Trail testify to his expertise as an explorer.

Although Bridger was in combat against warriors at least 15 times, he took three Native American wives. He sired several children, and his oldest daughter was sent to the Oregon mission school of Dr. Marcus Whitman, who had removed part of an arrow from Jim's back in 1835.

After two decades as a trapper, Bridger was forced out of the fur trade because of the declining demand for beaver pelts. From 1843 until 1853 he operated Fort Bridger, a trading post that catered to emigrants on the Oregon Trail. As Bridger prospered, he still found time to roam the West, becoming an army guide in 1849. On his first tour he showed the Corps of Engineers the future route for the Overland Stage, the pony express, and the Union Pacific Railroad.

Aside from his talents on the trail, one main reason for Bridger's popularity as a guide was his **knack for languages.** Although he was illiterate, he spoke English, Spanish, French, and about ten Native American tongues, and he was a master of the Plains sign language.

Best Mountain Man Movies

These films feature magnificent scenery, the adventurous culture of mountain men, and romances with Native American women.

Across the Wide Missouri (1951)

Clark Gable is a leader of fur trappers in Blackfoot country.

The Big Sky (1952)

Kirk Douglas (below), **Dewey Martin,** and **Arthur Hunnicutt** (Academy Award nomination) are on an expedition to obtain fur pelts and venture by keelboat up the Missouri River. ▼

Man in the Wilderness (1971)

Richard Harris is a real-life mountain man named Zachary Glass who is mauled by a grizzly and left to die.

Jeremiah Johnson (1972) ▼

Robert Redford is a mountain man who becomes an unwilling participant in a battle against the Crows.

The Mountain Men (1980)

Charlton Heston and **Brian Keith** bring the world of mountain men to life.

Battle of the Alamo

A **ferocious** and **crucial** battle took place in 1836 at an old Catholic mission in San Antonio, where fewer than **200 Texas patriots** fought against **thousands of Mexican soldiers** under the command of General Antonio López de Santa Anna.

Anglo settlers had rebelled against the dictatorship of Santa Anna in October 1835, soon **seizing** the Mexican capital of Texas, San Antonio. Santa Anna assembled an army and marched north, but his progress was blocked at San Antonio by Texans forted up in the Alamo.

Young firebrand **Colonel William Barret Travis** was in command of the little garrison, which featured frontier knife fighter **James Bowie** and former Tennessee member of Congress **Davy Crockett.** Stubbornly withstanding a **two-week siege,** the Texans finally were overwhelmed in a bloody assault on March 6, 1836.

Santa Anna suffered **devastating casualties** and spent another fortnight in San Antonio regrouping. The Alamo defenders cost Santa Anna the heart of his army and a month's delay. On April 21, when Sam Houston's outnumbered army charged to victory at San Jacinto, his men shouted, **"Remember the Alamo!"**

The Alamo chapel was roofless during the famous battle, but the walls were more than 20 feet tall and 2 feet thick. Years later, when the roof was added, the distinctive center hump was added to the facade.

Bowie Knife

Throughout frontier history, those who drank, gambled, and spent considerable time in taverns and saloons inevitably became involved in **violent** altercations. After the Colt revolver was introduced, such brawlers became gunfighters. But when early settlers carried **single-shot pistols,** they often had to resort to their knives. The premier knife fighter was legendary hunter **Jim Bowie.** Had Bowie lived a few decades later, he might have been a gunfighter; had Wild Bill Hickok lived a few decades earlier, he might have been a renowned knife fighter.

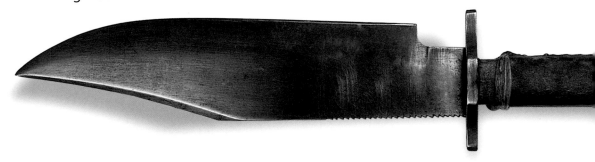

Many versions of the bowie knife featured a massive blade with a double cutting edge. When Davy Crockett saw Jim Bowie's famous knife, he observed that "you might tickle a fellow's ribs a long time with this little instrument before you'd make him laugh."

By 1830 Bowie wielded a **custom-made knife** with a 9- to 15-inch blade and a brass handguard used to parry an opponent's knife. The heavy blade had a cutting edge on both sides so that a **backstroke** could inflict injury, and the knife was **balanced** for throwing. Originally intended as a hunter's tool, the bowie knife proved effective in **close-quarter fighting** too, and variations of it were put to multiple uses all across the West.

KIT CARSON

1809—1868

Christopher Houston "Kit" Carson became a legend in his own time, living long enough to see his frontier adventures reinvented in dime novels.

Raised in Missouri, he was apprenticed as a teenager to a saddlemaker. Feeling restless, he defiantly left home in 1826 and was hired on as a herder with a caravan bound for Santa Fe. The saddlers offered a reward of one penny for his return.

From Santa Fe he ventured to Taos. The young adventurer fell in love with the locale and made Taos his home base for the rest of his life. For the next several years, Carson ranged throughout the Rockies working as a fur trapper. He learned Native American customs and languages, but he also fought on numerous occasions against hostile warriors. From 1829 through 1864, he engaged in approximately 30 skirmishes and battles against warriors from various tribes.

The rendezvous of 1835 proved unusually eventful for Carson. He shot a bullying trapper named Shunar in a mounted duel. He also traded for his first wife, a beautiful Arapaho maiden named Waanike, who gave birth to two children. Sadly, Waanike died of illness around 1838.

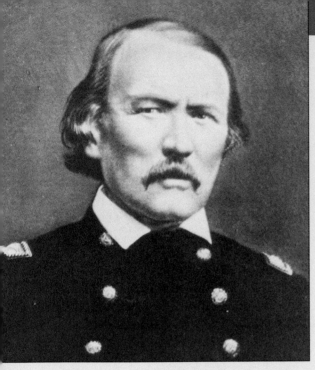

In 1842 Carson was hired as a guide for $100 a month by Lieutenant John C. Frémont. Over the next four years, Carson accompanied Frémont as guide and hunter on three explorations across much of the West.

Assigned to carry dispatches to Washington, D.C., Carson reached the nation's capital to find that he had become famous.

Back in New Mexico he was appointed an American Indian agent, and he served honestly and well for a decade. Many reservation American Indians called him "Father Kit." During the Civil War he became lieutenant colonel of the First New Mexico Volunteer Infantry. By 1864 Carson was a brigadier general, and he commanded a punitive expedition into the Texas panhandle. During the ensuing Battle of Adobe Walls, Colonel Carson dueled 2,000 warriors—more than any other commander until George Armstrong Custer in 1876.

Carson married Josefa Jaramillo in 1843, but she died in 1868 following the birth of their seventh child. Bereaved and in bad health, Carson died a month later.

JOHN C. FRÉMONT

1813—1890

Allan Nevins, the most noted of John C. Frémont's biographers, entitled his two-volume study *Frémont, the West's Greatest Adventurer.* Frémont lived up to this label during his years as a daring explorer, exhibiting courage and endurance to a heroic degree.

Frémont was personable and handsome, with an aptitude for attracting benefactors—including one who provided a college education and another who arranged a commission with the U.S. Topographical Corps. On wilderness expeditions with the Corps, Frémont acquired expert training and a taste for exploration.

Lieutenant Frémont impressed Missouri Senator Thomas Hart Benton, a powerful spokesperson for westward expansion. Another member of the family who aided his career was Benton's remarkable daughter, Jessie. When Frémont returned from an 1841 expedition into Iowa Territory, he married Jessie. She eventually bore him five children, worked behind the scenes on his behalf, and provided him with publicity and financial support via her literary efforts.

Senator Benton and others interested in the American acquisition of the Oregon country obtained authorization for an 1842 expedition along the

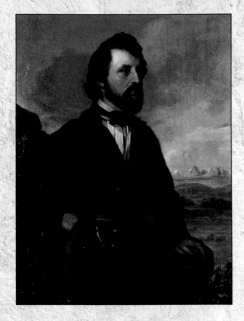

Oregon Trail. The incomparable scout Kit Carson guided the party of 26 people, which was commanded by Frémont. An account of this adventure, prepared by husband and wife, excited the public and made John C. Frémont a household name.

Prompted by Benton, Congress authorized a second and far more extensive exploration. Frémont, Carson, and 40 others were gone for more than a year, journeying to Oregon, California, the Great Salt Lake, and Santa Fe. By the time Frémont returned to St. Louis in 1844, expansionist James K. Polk was conducting a successful presidential campaign. In 1845 President Polk sent Frémont, again guided by Carson, back to California. When Frémont arrived, the Mexican War had begun, and the expedition fought in several California skirmishes.

In 1856 Frémont made a good showing as the first presidential candidate of the newly organized Republican Party (he was defeated by James Buchanan). During the Civil War Frémont was appointed a major general, but military controversies caused his resignation. The aging hero returned to the West as territorial governor of Arizona from 1878 through 1883.

Homesteaders

When a sod house was built against a hill, only three walls had to be constructed, but the grass roof had to be fenced off because cows would wander onto it to graze—and collapse the roof!

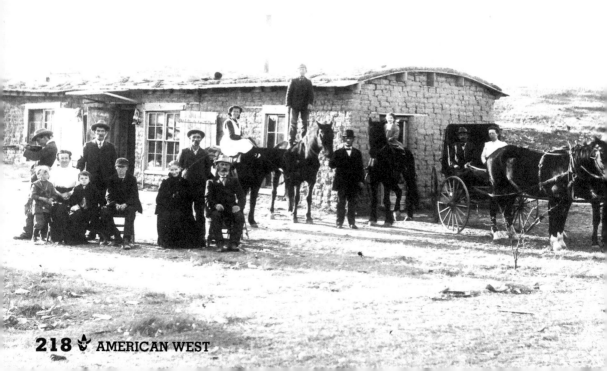

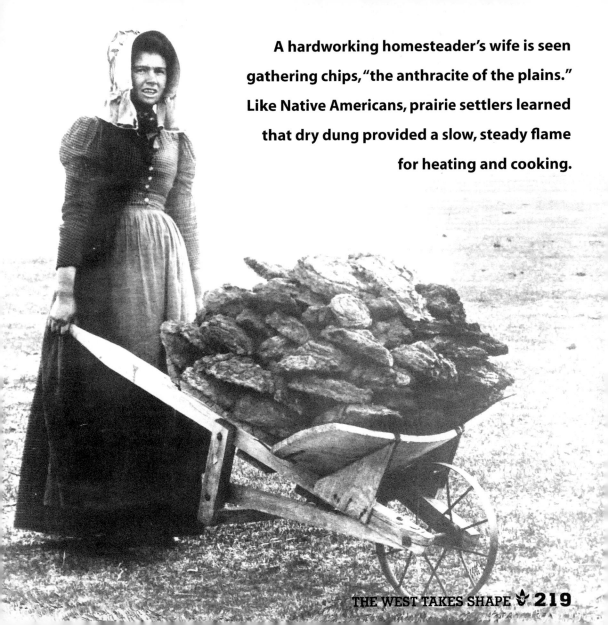

A hardworking homesteader's wife is seen gathering chips, "the anthracite of the plains." Like Native Americans, prairie settlers learned that dry dung provided a slow, steady flame for heating and cooking.

Windmills

When the westward movement reached the arid Great Plains, settlers found few streams that ran year-round. Subterranean water often was hundreds of feet deep, rendering impracticable the shallow, hand-dug wells of the East.

An adaptation of the ancient windmill provided a solution. The Great Plains were ceaselessly swept by brisk winds at velocities averaging 12 to 14 miles per hour. This free source of power could be harnessed mechanically to pump water up from deep levels. In the 1850s a Connecticut mechanic named Daniel Halladay with the help of a governor fashioned a windmill to reduce the pitch of the blades in high wind, keeping them from spinning so rapidly that the machine would be torn apart. A simple vertical fin kept the mill headed into the wind. A crankshaft converted the rotary motion of the blades to the up-and-down action required to pump water.

Well drillers charged $1.25 to $2.00 per foot for wells, which sometimes extended 50 to 500 feet deep. A windmill might cost $100, running the price for a well and mill to perhaps $1,000—prohibitive for an early homesteader. But ranchers, railroad towns, and prosperous farmers drilled wells and planted windmills, so that 16 factories totaled annual sales exceeding one million dollars by 1879. By the 1890s reduced production costs and rising farm income allowed more and more farmers the convenience of a mechanical water supply.

A mill could lift hundreds of gallons of water a day. The tallest windmill in the West was located in the Yellow Houses Division of the three-million-acre XIT Ranch in the Texas panhandle. At Yellow Houses' headquarters, water was found at a depth of just 40 feet, but the headquarters was located in a sheltered canyon. The mill's tower was built 130 feet tall to catch the winds above canyon walls.

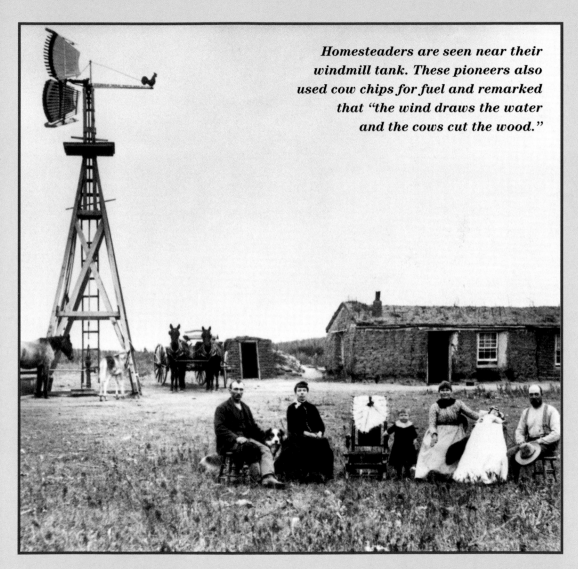

Homesteaders are seen near their windmill tank. These pioneers also used cow chips for fuel and remarked that "the wind draws the water and the cows cut the wood."

BARBED WIRE

The traditional split-rail fence used in the East **could not be built** on the tree-less Great Plains, and it was **impossible** to settle a piece of land without some effective way of keeping out what wasn't yours. Smooth wire was tried as a fencing material, but hungry cattle and buffalo could break the harmless fencing and ravage a field of crops. **Thorny shrubs** were planted, but the rugged steers were able to eat their way through this ineffective barrier. **Wire with barbs** proved to be an impassable obstacle to animals, but there were significant manufacturing problems. Early versions had barbs that were large enough to cut the hides of horses and cows, but this impractical fencing was too expensive to manufacture and market profitably.

But near DeKalb, Illinois, **Joseph Glidden** worked to find an **inexpensive** method of enclosing his 600-acre farm. By 1874 he had devised a way to **twist** together two strands of wire so that they could hold pointed barbs. Glidden patented his wire, rented a small factory in DeKalb, and began manufacturing. Sales exploded from three million pounds of barbed wire fence in 1876 to 12 million pounds the next year, 50 million pounds in 1879, and 80 million in 1880.

There was so little wood on the Great Plains that fence posts to hold the wire had to be shipped. But Nebraska settlers learned to produce **stone**

During the decade after the Civil War, 122 types of fencing were patented. Most were impractical, but Joseph Glidden invented a simple, inexpensive method of twisting barbs through two strands of wire.

fence posts from layers of sediment a few inches deep that had been formed by ancient seas. During the winter, innovative settlers would drill a double line of holes the desired length of the fence post. When precipitation froze in these holes, the expansion produced a **perforation** effect. The resulting stone fence posts were lifted up and put into place, and many of them still stand today.

The Telegraph

During the 1850s, the development of the California gold fields, half a continent from the line of western settlement, created a desperate need for rapid communication. The Butterfield stagecoach line delivered mail in a little more than three weeks, and the short-lived but colorful pony express cut that to ten days. But the real promise of faster communication lay in the electromagnetic telegraph, developed by Samuel F. B. Morse in 1844.

The capital required to build a telegraph line was comparatively modest, and the California State Telegraph Company was formed in 1853. Lines were extended from San Francisco to numerous communities, and a connection was established with Los Angeles in 1860. That same year Congress passed the Telegraph Act of 1860, providing $40,000 annually for ten years to any company that would build a line from Missouri to San Francisco.

The Overland Telegraph Company was formed to build a line from Carson City, Nevada, to Salt Lake City. A telegraph line already extended from the

East to Omaha, and the Western Union Telegraph Company organized the Pacific Telegraph Company to construct a line westward toward Salt Lake City.

Overland Telegraph Company construction crews could obtain the needed glass insulators and wire only by sea around South America. The acquisition and delivery of poles to

The first coast-to-coast telegraph was completed in October 1861, driving the famous pony express out of business—even though the rates for the telegraph were as high as 75 cents a word.

crews on the treeless Great Plains involved incredible difficulties. Warriors sometimes raided construction workers or cut lines.

But these and other difficulties were overcome with admirable resourcefulness. The lines were joined on October 24, 1861, far earlier than had been expected. President Abraham Lincoln received a telegram that the East and the West were connected by telegraph and that California would remain loyal during the war that had erupted between the North and the South.

Railroads

The steam railroad was invented in England, but it was perfected in the United States, which stretches 3,000 miles from coast to coast. As tracks were built across the West after the Civil War, railroads became perhaps the most significant factor in the settlement of the frontier.

Construction began on the first transcontinental railroad in 1863. Irish immigrants and Civil War veterans laboring for the Union Pacific Railroad Company laid track westward, while the Central Pacific Railroad Company, relying primarily on Chinese immigrant labor, built eastward from California to meet them. Each company used 10,000 employees, the largest workforces America had ever seen. The federal government provided funding in the form of loans and land allotments for each mile of track laid. The east-west lines met on May 10, 1869, at Promontory Point, Utah, completing what was then regarded as the world's greatest engineering feat.

Federal subsidies soon were extended to three other transcontinentals. The Northern Pacific; the Southern Pacific; and the Atchison, Topeka & Santa Fe were completed in the 1880s. A total of 174 million acres of public lands were granted to the railroads. A final transcontinental, the Great Northern, was refused government subsidies, but promoter James J. Hill resourcefully managed to construct the line by 1893. By this time, numerous connecting lines also had been built.

The need to transport freight, livestock, and passengers was crucial to the existence of the railroads, so land was aggressively advertised for sale at bar-

gain prices throughout the East and Europe. Towns flourished beside railroad tracks across the West. Freight transportation invigorated the western economy, and passenger traffic was revolutionized throughout the West. But rustlers, bandits, and murderers found that escape routes were blocked and posse pursuits were greatly facilitated by the newly created rail lines. The "iron horse" played a major role in the conquest of the West.

This illustration shows a train racing across the Plains ahead of a prairie fire. Blizzards and buffalo herds crossing the tracks were other obstacles faced by westward railroaders.

Five Great Railroad Movies

The Great Train Robbery (1903)

Inspired by the turn-of-the-century misdeeds of the Wild Bunch, this 12-minute landmark Western was the first film to tell a story. Actor **Gilbert "Broncho Billy" Anderson** soon became the screen's first cowboy star.

The Iron Horse (1924)

Master director **John Ford**'s epic silent Western depicts the construction of the first transcontinental railroad.

Union Pacific (1939)

Joel McCrea, Barbara Stanwyck, and **Robert Preston** star in Cecil B. DeMille's spectacular retelling of the first transcontinental, climaxing with the famous driving of the golden spike.

Whispering Smith (1948) ▼
Alan Ladd is a railroad detective closing in on train robber **Robert Preston.**
The movie contains superb details of western railroading.

Night Passage (1957)
James Stewart is a railroad troubleshooter battling a gang of train robbers
that includes his brother, **Audie Murphy.** The movie was filmed on the
narrow-gauge Durango & Silverton RR.

Movie Moment:
In ***Duel in the Sun,*** train robber **Gregory Peck** leaves the site of a violent
holdup whistling "I've Been Working on the Railroad."

Harvey Houses

"A Fairer Maiden I shall never see," rhapsodized S. E. Kiser, a songwriter from the day about a Harvey girl. "She was winsome, she was neat, she was gloriously sweet, and she certainly was very good to me." Thousands of Harvey Girls waited tables at Harvey Houses across the West, and no fewer than **5,000 found husbands** among their western clientele.

Early western railroads had no dining cars, and ten-minute food stops required a mad rush to seize and gulp down refreshment at a trackside restaurant before the train pulled out again. **Frederick Henry Harvey,** a veteran operator of railroad restaurants, recognized the opportunity, and he began arrangements to organize **quality food operations** along the Atchison, Topeka & Santa Fe line. In time, he operated 47 depot restaurants, 15 railroad hotels (several of which still stand), and 30 dining cars.

A key to his success was staffing each Harvey House with **Harvey Girls.** Many eager applicants responded to his ads for **"young women of good character, attractive and intelligent, 18 to 30."** The servers lived in a Harvey House dormitory with a chaperoned courting room and a ten-o'clock curfew. Easily identified by their large, starched white aprons, Harvey Girls earned $17.50 per month plus tips, along with room and board.

When Harvey died in 1901, the business was taken over by his son, Ford Ferguson Harvey. Renaming the business **"Fred Harvey's,"** Ford's expansions included the Grand Canyon National Park concessions and famous hotels such as the picturesque La Fonda in Santa Fe. By this time western tourism was expanding rapidly, and Fred Harvey's was busier than ever. Although Ford Ferguson Harvey died in 1928, the business continued to thrive until passenger trains in the West were eventually eliminated by automobiles and airplanes.

Blue Jeans

Levi Strauss was 18 in 1847 when he immigrated to the United States from his native Bavaria to work as a merchant in New York. In 1853 he decided to join a brother-in-law, **David Stern,** in the dry-goods business in San Francisco.

Embarking with a supply of cloth, Strauss sold almost all of it en route, arriving in California with a single bolt of canvas tent cloth. As he stepped ashore in San Francisco, he met a miner for whom he promptly designed a pair of **heavy canvas** pants. Recognizing opportunity, Strauss bought large quantities of canvas **sailcloth** from ships that stood empty in San Francisco Bay, deserted by sailors bound for the gold fields. Rapidly producing durable canvas pants for miners, within a year Strauss and Stern had become **California's largest pant makers** after switching from canvas to heavyweight blue denim.

The tough pants with copper rivets quickly became known as **blue jeans** or **Levi's,** and they were immensely popular among the western workers. **Levi Strauss & Company** was incorporated in 1890, and the San Francisco plant employed 500 workers to meet the

demand. Strauss, who now could claim the most famous first name in the West, grossed **one million dollars annually.** He died in 1902, but four nephews continued to produce Levi's.

At first cowhands **resisted** the sturdy denim pants, looking on them as the **uniform** of farmers, miners, and other sedentary toilers that the cowboys so disdained. In time, though, Levi's became regulation wear for cowboys. **Turned-up cuffs,** used to hold horseshoe nails while shoeing horses, became fashionable. By the early 1900s Levi's often were worn with shirts sporting snap buttons. Rodeo cowboys, who sometimes were caught on saddle horns by unyielding shirt fronts after being bucked off, requested **snap buttons** so they could quickly free themselves from a wild bronc.

Levi Strauss produced the most popular trousers among Westerners and enjoyed the most famous first name in the West.

The Mail-Order Catalog

A flood of cheap manufactured goods produced by American industry was made available to eastern customers via department stores. But rural Westerners were excluded from this variety of products—until Montgomery Ward brought shopping to the country through catalog buying.

After the Civil War, farmers began to organize cooperative buying and selling, as well as for united political action. The first farmers' organization was the Patrons of Husbandry, popularly known as the Grange. Recognizing the possibilities of direct selling to vast numbers of newly organized farmers, Montgomery Ward and Company opened its doors in 1872 specifically to "meet the wants of the Patrons of Husbandry." The primary device for selling to isolated farm families was the catalog, an illustrated list of goods detailing prices, sizes, colors, and other tempting information.

Aaron Montgomery Ward worked as a dry-goods salesperson across the West. Hearing complaints about high prices in general stores, Ward bought $1,600 worth of goods and from a 12×14-foot room in Chicago published a sheet listing 163 items. By 1875 his catalog had grown to 72 pages with nearly 2,000 articles, and within two decades the 624-page catalog offered 75,000 items. The only significant problem was shipping rates, but in 1896 Congress enacted Rural Free Delivery.

Rural residents of remote homesteads and ranches welcomed the "wishbooks" from Ward's company. On parlor tables, a "Monkey Ward" wishbook was placed beside the King James Bible. Little girls would gaze at dolls, boys would examine pocketknives, mothers did their window-shopping through the pages, and fathers priced tools and boots. Last year's books went to the outhouse for perusing and for tearing out pages to use as toilet paper (instead of the customary pile of corn-cobs).

This is a Sears, Roebuck wishbook. Although Sears, Roebuck is indelibly identified with catalog buying, the business was pioneered by Montgomery Ward.

GEORGE CATLIN

1796—1872

Mesmerized by Native Americans, George Catlin became the first artist of consequence to record western tribal groups and their way of life. His mother had been captured by Native Americans as a little girl, and he grew up hearing exciting tales of frontier adventures.

Catlin briefly practiced law, but he soon yielded to his passion for art. Teaching himself to paint, he moved to Philadelphia to establish himself as a portrait artist. In 1824 Catlin encountered a group of 15 western

chieftains on a tour of the East, and he resolved to preserve on canvas the Native Americans of the West before they became "corrupted by civilization."

The artist journeyed to St. Louis and gained the support of famed explorer William Clark, who was Superintendent of Indian Affairs for the vast western region acquired through the Louisiana Purchase. Catlin accompanied Clark to treaty councils, then traveled to Fort Leavenworth, Fort Laramie, and perhaps as far as the Great Salt Lake.

In 1832 Catlin boarded the American Fur Company's new steamboat, *Yellow Stone*, for a trip up the Missouri to western trading posts. As he came across new tribes, he sketched and painted rapidly, producing as many as six works in a single day. He carefully produced portraits with intricate details of dress, equipment, decoration, and hairstyle, but he used broad strokes for the backgrounds, which could be filled in later. He also recorded village scenes, religious ceremonies, and domestic activities. Sensing his genuine admiration, the tribe members readily accepted "the great medicine painter."

In six years Catlin produced more than 600 scenes and portraits of 48 tribal groups. It was a timely endeavor, because smallpox and other diseases, along with warfare with the Europeans, had already taken a terrible toll on the tribes. The way of life Catlin recorded would soon vanish. Although he was not a technically accomplished artist, the exotic nature of his subject matter exerted a magnetic appeal on the public.

In 1832 George Catlin painted a Mandan "Bull Dance."

Albert Bierstadt
1830–1902

Albert Bierstadt was born in Germany in 1830, but the next year his family immigrated to Massachusetts. He returned to Germany in his 20s to study painting, with sketching trips to the Alps.

❦ ❦ ❦

Bierstadt came back to the United States in 1858, yearning to see the fabled Rocky Mountains. At his own expense he accompanied a military expedition surveying a wagon road west of Fort Laramie, and in 1863 he journeyed all the way to California.

❦ ❦ ❦

In his New York studio he translated his field sketches into great canvases appropriate to the overwhelming dimensions of the West. *The Rocky Mountains,* for example, was painted on 60 square feet of canvas.

❦ ❦ ❦

Bierstadt's 1863 painting, *The Rocky Mountains, Lander's Peak,* sold for $25,000 to a London collector after his 1864 New York exhibition, a record price for an American landscape.

❦ ❦ ❦

One of the mountains in the Rockies, with a 14,060-foot peak, was named Mount Bierstadt in his honor.

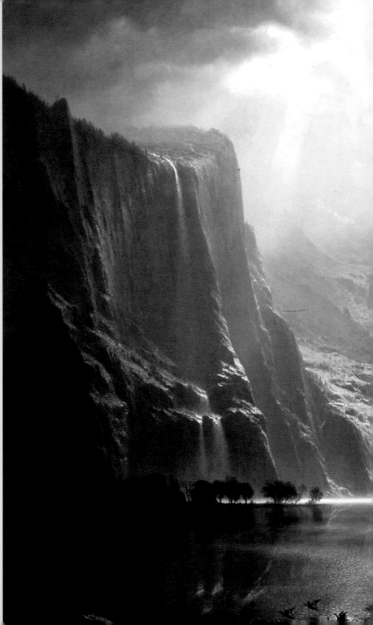

Albert Bierstadt, a native of Germany, completed "Among the Sierra Nevada Mountains" in 1868. It is one of Bierstadt's numerous romantic landscapes that captured public appeal. Bierstadt was overwhelmed by the magnificent vistas of the West, and he depicted that grandeur in enormous, dramatic paintings worthy of the expansive spirit of the frontier. For Bierstadt, nature was a starting point, and he romanticized the western landscape as an Eden, with shimmering lakes, golden shafts of light, and towering peaks.

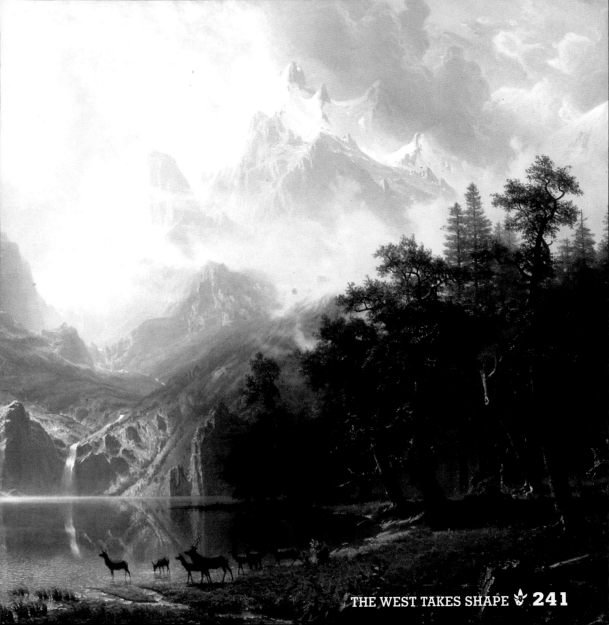

JAMES FENIMORE COOPER

1789—1851

Novelist James Fenimore Cooper exerted a deep and lasting influence upon later generations of western writers. He was raised in Cooperstown, New York, which was founded by his father. James married another member of the landowning class, but while living the life of a country squire he began writing novels.

His production was prolific, but his most important work was the Leatherstocking series including *The Pioneers* (1823), *The Last of the Mohicans* (1826), *The Prairie* (1827), *The Pathfinder* (1840), and *The Deerslayer* (1841). The books span the life of central character Natty Bumppo, a skilled hunter and frontiersperson whose closest companion is Chingachgook, the last of the Mohicans.

With loyalties to both the European and American Indian worlds, Bumppo engages in perilous, exciting adventures through a long life on the frontier. Later western writers employed both the basic outline of Cooper's stirring plots and the ambiguity of a character torn between two conflicting ideologies.

MARK TWAIN

1835—1910

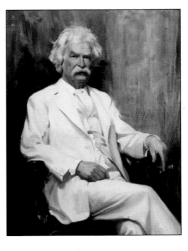

Samuel Clemens was a 25-year-old steamboat pilot when the Civil War began, but the closing of the Mississippi ended his career on the river. His brother, Orion, was appointed secretary to the territorial governor of Nevada, and Sam accompanied him on the long stagecoach ride to the West in 1861. In Nevada, Sam unsuccessfully tried his hand at prospecting and then won a reporter's job with the *Territorial Enterprise* in Virginia City. He wrote under the byline "Mark Twain," a nautical term from his riverboat days.

In 1865 Twain published a short story, "The Celebrated Jumping Frog of Calaveras County," in the *New York Saturday Press*. This typical western tall tale launched the literary career of one of America's greatest writers. *Roughing It*, the delightful 1872 account of Twain's western adventures, related the story of his travels through the eyes of a greenhorn Easterner who is perplexed but entertained by colorful western characters and events. Artfully capturing the rough humor and courageous optimism of frontiersmen, *Roughing It* is a first-person classic about the Old West.

ZANE GREY

1872–1939

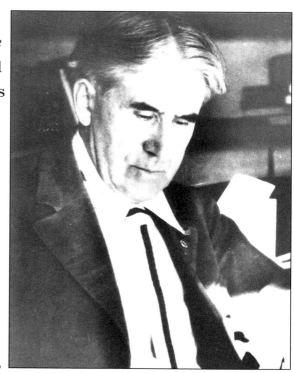

Zane Grey was a 31-year-old dentist when he published *Betty Zane* in 1903, the first of three historical novels about his pioneer ancestors on the Ohio frontier. His early work was not successful, but in 1906 he made his first of many trips to the Southwest, where he would camp, fish, hunt, and explore—and collect material for western novels.

His first great hit came in 1912 with *Riders of the Purple Sage,* a sweeping romance featuring his most memorable character,

a gunfighter known as Lassiter. It became the first of 48 Zane Grey novels purchased for the screen and would eventually be filmed four times. More than 100 motion pictures have been based on Grey's books, a record unmatched by any other author. Grey wrote in bursts, often late at night after his family had gone to bed, producing a total of 78 volumes. He died at his California home in 1939 at the age of 67.

"How can the truth be told about the pioneering of the West if the struggle, the fight, the blood be left out? It cannot be done. How can a novel be stirring and thrilling, as were those times, unless it be full of sensation? My long labors have been devoted to making stories resemble the times they depict. I have loved the West for its vastness, its contrast, its beauty and color and life, for its wildness and violence. . . ."

Best Western Novels

The Virginian
Owen Wister (1902)

Warlock
Oakley Hall (1958)

Riders of the Purple Sage
Zane Grey (1912)

True Grit
Charles Portis (1968)

The Wonderful Country
Tom Lea (1952)

The Cowboys
William Dale Jennings (1971)

Hondo
Louis L'Amour (1953)

Open Range
Lauran Paine (1990)

The Tall Men
Clay Fisher (1954)

The Unforgiven
Alan LeMay (1957)

Larry McMurtry's *Lonesome Dove* stands in a category by itself. Published in 1985, the sprawling, humorous novel won the Pulitzer Prize, then was adapted into a spectacularly popular miniseries starring Robert Duvall and Tommy Lee Jones.

Best Western TV Series

Cheyenne
(1955–63)

Gunsmoke
(1955–75)

Maverick
(1957–62)

Have Gun, Will Travel
(1957–63)

Wagon Train
(1957–65)

Wanted: Dead or Alive
(1958–61)

Bonanza
(1959–73)

The Virginian
(1962–71)

The Big Valley
(1965–69)

Deadwood
(2004–06)

☆ ☆ ☆

The best Westerns for children during
the early years of TV were:

Hopalong Cassidy
(1949–51)

The Lone Ranger
(1949–57)

The Gene Autry Show
(1950–56)

The Roy Rogers Show
(1951–57)

JOHN WESLEY POWELL

1834—1902

Captain John Wesley Powell, future explorer of the Colorado River, commanded a Union artillery battery during the Battle of Shiloh. When he raised his arm to signal his battery to fire, a Confederate bullet shattered his elbow. His right forearm was amputated, but he returned to action and earned promotion to major.

The oldest son of a Methodist minister, Powell had been a teacher since the age of 18. After the war, Major Powell was a college lecturer and museum curator who led extended field trips into the Rocky Mountains.

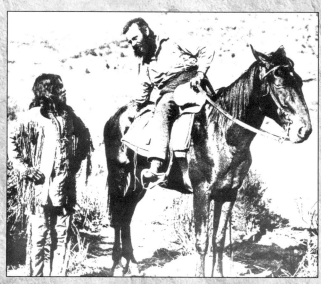

There had been previous surveys of the Colorado River, but 150 perilous miles remained unexplored. Major

Powell secured donations, supervised the construction of three heavy boats, and enlisted 11 people. The 1869 expedition overcame furious currents and treacherous rapids in the Grand Canyon. One boat was shattered, supplies were lost, and three people deserted and were then killed by hostile warriors.

The one-armed Powell rode horseback, helped muscle boats through the rapids of the Colorado River, and clambered up the steep walls of the Grand Canyon.

Powell and his surviving members emerged to public acclaim, which he expanded with a lecture tour. He organized another Colorado River expedition in 1871, then other trips to other rugged locales. Powell was appointed director of the U.S. Geological Survey in 1881, a position he held with distinction for 14 years.

———❧———

"I had a pair of buckskin breeches. They were so wet all of the time that they kept stretching and I kept cutting off the lower ends till I had nothing left but the waist band. I cut holes in my shirt tail and tied the loose ends around my legs."

—Billy Hawkins' account of the 1869 expedition with Powell, as related in a 1907 letter to Robert Brewster Stanton

WILLIAM HENRY JACKSON

1843—1942

Destined to become the most famous of early western photographers, William Henry Jackson was running a photographic studio in Troy, New York, when he was 15. His first trek west came in 1866, when he traveled to California.

A year later Jackson opened a studio in Omaha, Nebraska, and photographed construction of the Union Pacific Railroad. In 1870 pioneer geologist F. V. Hayden walked into Jackson's studio, inspected the photographs on display, then announced, "This is what I need."

Hayden was preparing to lead the first scientific party into Yellowstone country, and he wanted to employ a photographer who would provide a precise visual record of the region. Jackson's imagination was triggered, and within a week he was headed for the Rockies with Hayden.

Hayden provided an old army ambulance into which Jackson packed his bulky cameras, glass plates, chemicals, and other equipment, although in the mountains the gear would have to be carried by mules. Painter Thomas Moran also accompanied Hayden, and the wiry artist often helped Jackson lug his unwieldy equipment.

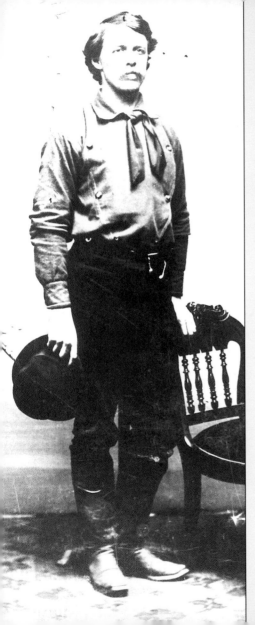

Jackson's eye for dramatic composition—and his sheer physical stamina—produced a magnificent photographic record of Yellowstone country. Hayden, lobbying for the creation of Yellowstone National Park, exhibited Moran's paintings to Congress, then distributed a portfolio of Jackson's impressive photographs to each member of Congress. The bill authorizing the first U.S. national park passed unanimously.

Jackson continued to accompany Hayden's expeditions through 1878. During the 1870s he produced thousands of western landscapes, photos of Native American camps and cliff dwellings, and other scenes notable for their historical interest and sheer beauty.

Later in life Jackson took up painting, and when he was 93 he produced Old West murals for the new Interior Department building. The tireless chronicler of the last frontier lived until the age of 99.

William Henry Jackson first worked in the West in 1866, but he continued to return, photographing Wyoming's Devil's Gate Bridge early in the twentieth century.

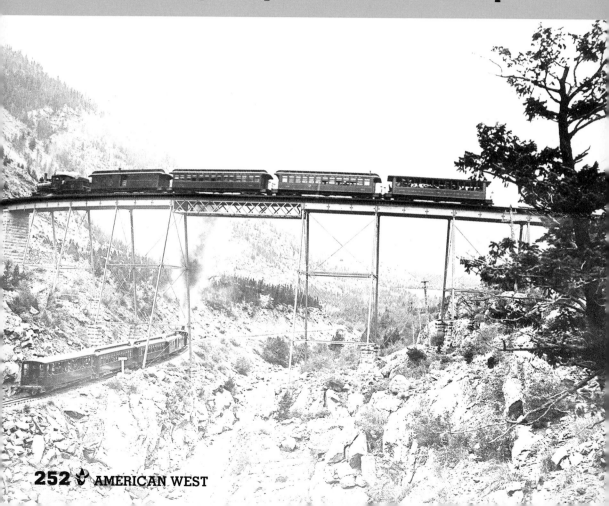

Stand 'Em Up Straight

Part of the photographic history of the West was the **display of outlaw corpses.** After a criminal was shot to death—perhaps by law officers, perhaps by citizens during a robbery attempt—the **dead person** was placed on a board, then propped up so that the officer or citizen who had fired the fatal shot could **stand proudly beside his prey.** The outlaw's rifle often would be placed in his **lifeless** hands, and his mask might be fitted over his face.

After he was shot, Tulsa Jack Blake's body was on display.

 When Grat Dalton died of a wound to the neck at Coffeyville, citizens **pumped his arms** up and down to watch the **blood spurt,** then lifted him up so they could be photographed beside the notorious outlaw.

CHARLES RUSSELL

1864—1926

"**I**'m glad I lived when I did—not 20 years later," reflected cowboy artist Charles Russell near the end of his life. "I saw things when they were new."

Raised on a Missouri farm, Russell was fascinated by frontier lore. He also was preoccupied with modeling clay figures and with sketching. Little attention remained for the three R's, so his parents shipped him off to a New Jersey military school.

But when he was 16, Russell wrangled a summer trip to Montana and promptly adopted the magnificent territory as his homeland. He worked on a sheep ranch, spent two years with a hunter-trapper, lived for six months with Blood Indians, and rode as a night herder for 11 years.

Night herders enjoyed considerable free time during daylight hours, and the observant Russell matured rapidly as an artist. Cowboys, mountain men, warriors, gunfighters, buffalos, broncos—he brought the West to life in brilliant colors and with an accuracy of detail so keen that early day Montana cowboys could be identified by items of clothing or equipment, or by the way they sat in a saddle or held a lariat. The fame of the "cowboy artist" grew, and in 1918 Russell left the range: "I never sang to the horses and cattle again."

In 1896 Russell married a woman 14 years his junior, but Nancy Russell proved to be a stabilizing influence on his life and career. She curtailed his drinking sessions with old cronies and became his agent, negotiating sales and commissions that astounded Charles. They purchased a two-story Victo-

rian house in Great Falls, Montana, and beside it Charles built a log studio, cluttered with Native American artifacts and cowboy gear.

Charles's production of oils, watercolors, and bronzes accelerated in number and technique. The Russells could afford to travel frequently to New York, winter in California, and visit Europe. But Charles's health failed, and at 62 he died of a heart attack at his home in Great Falls.

"The Scout" is one of many of Charles Russell's paintings that depicted the heroic past of the horse warriors.

FREDERIC REMINGTON

1861–1909

Beset by problems regarding his sweetheart, a series of unsatisfying jobs, and the death of his father, New Yorker Frederic Remington treated himself to a trip to Montana. Remington found the West of 1880 exhilarating and its inhabitants fascinating.

Already a fine horse rider, Remington learned the cowboy arts of handling a lariat and a six-gun. Around a campfire an old-timer convincingly pointed out that the railroad would tame the last frontier, and Remington decided to record this vanishing way of life.

During two years as an art student at Yale, Remington had received sound technical training, and he began to fill sketchbooks with cowboys, horses, cattle, roundups, prospectors, members of the cavalry, warriors, and American Indian camps. He traveled across the West, prospecting, cowboying, and riding with military expeditions.

Remington returned to New York City in 1885, and after a discouraging year spent trying to peddle his art, *Harper's Weekly* used one of his pieces

Frederic Remington in 1889 works on "An Indian Trapper." Remington equipped his studio with weapons, equipment, clothing, and other frontier artifacts.

as a cover illustration. Soon he became one of the highest paid illustrators in the world. Although Remington died at 48 of complications from appendicitis, he published illustrations in 142 books and 41 magazines and produced more than 2,700 paintings and drawings in his last 20 years of life.

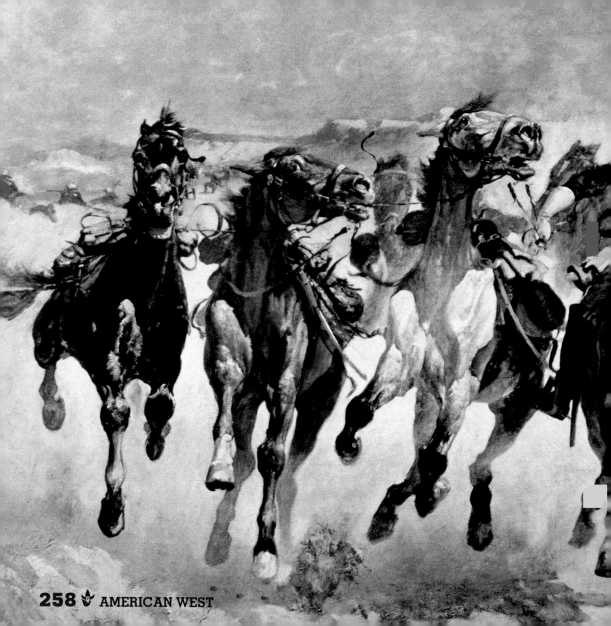

"I knew the wild riders and the vacant land were about to vanish forever—and the more I considered the subject, the bigger the *forever* loomed."

The cavalry was a favorite subject of Frederic Remington. This scene depicts mounts being led to the rear; when troopers dismounted to fight as skirmishers, every fourth person served as a horse holder.

Along the Great Frontier

Along the great frontier, Westerners built towns, forts, farms, and ranches, giving shape to America's West.

"There were military companies, fire companies, brass bands, banks, hotels, theatres, hurdy-gurdy houses, wide-open gambling palaces, political powwows, civic processions, street fights, murders, inquests, riots, a whiskey mill every fifteen steps, . . . a dozen breweries and half a dozen jails and stationhouses in full operation, and some talk of building a church."

—*Mark Twain,* Roughing It

Fort Bridger, Wyoming

At the Black Fork of Wyoming's Green River, noted explorer and scout Jim Bridger, along with his partner Louis Vasquez, established a stockaded trading post in 1843. Fort Bridger catered to emigrants on the Oregon Trail, providing wagon repairs, provisions, and livestock trading. Warriors occasionally tried to raid the large horse herds, and in 1846 the ill-fated Donner Party stopped over on its way to California.

Bridger prospered, but a conflict with the Mormons resulted in his departure in 1853. Vasquez sold Fort Bridger to the Mormons two years later, but the U.S. Army acquired it in 1858. Fort Bridger became a major post with substantial buildings before the Army left in 1890. Located in a serene setting, Fort Bridger's grassy parade ground is bisected by a rushing stream.

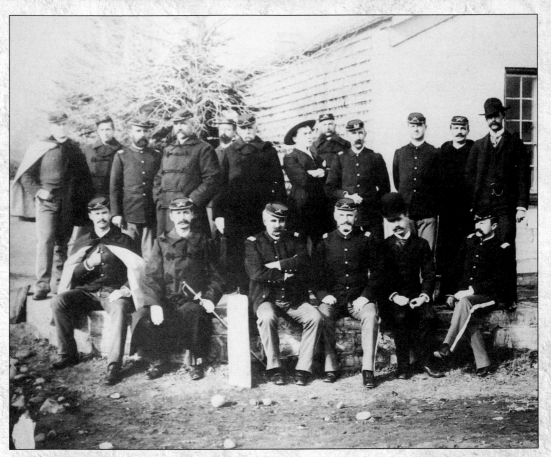

Officers congregate in front of Fort Bridger during the early 1870s. The fort originated in 1843 as a trading post established by famed mountain man Jim Bridger.

Old Bent's Fort, Colorado

In 1828 Charles, Robert, George, and William Bent, and their partner Ceran St. Vrain, built an adobe trading post on the north bank of the Arkansas River. The walls were 4 feet thick and 15 feet tall, with round bastions at two corners. There were cannons in the bastions, and cacti were placed atop the walls to deter scaling. The fort's walls were 180 feet long and 135 feet wide.

This is a crudely drawn image of Old Bent's Fort.

Providing a supply base and a fortified refuge from war parties, Old Bent's Fort quickly became the key stopover on the Santa Fe Trail. John C. Frémont led his explorers out of Old Bent's Fort into the Rockies, and the Army frequently stationed soldiers there. During this time William repeatedly tried to sell the post to the government. In 1849, disgusted over government refusal to buy, William moved out, then blew up the outpost.

William Bent then built a smaller version of Old Bent's Fort 38 miles downstream. More than a century later, the United States Park Service rebuilt Old Bent's Fort on the original stone foundations.

Army Posts

Forts erected throughout the West were **military communities** that provided significant **economic** benefit to the frontier as well as protection from hostile Native Americans.

When the army built a fort at some remote western location, a "hog ranch" sprang up nearby. A couple of dives offered whiskey, gambling, and girls to soldiers, and a general store took its share of the military payroll. Soldiers and horses at the fort consumed meat and vegetables, hay and grain. As farmers and ranchers settled nearby to meet these needs, hog ranches grew into towns. Forts and their adjacent towns provided **pockets of civilization** across the West. Fort Worth developed into a major Texas city, and Dodge City (from nearby Fort Dodge) became a famed Kansas cattle town. Other hog ranch communities also evolved into prominent cities.

A few frontier forts later expanded into large modern bases, such as Fort Bliss in El Paso, Texas, and Fort D.A. Russell, now Warren Air Force Base in Cheyenne, Wyoming. While most of the outposts were abandoned when the Indian Wars ended, many are maintained as historic sites—**fascinating military ghost towns.**

Fort Laramie, Wyoming

Unlike the stuff of Hollywood movies, Fort Laramie was not surrounded by a stockade with sharpshooters stationed along the ramparts. Fort Laramie originated in 1834 as a trading post built by fur traders at the junction of the Laramie and North Platte rivers. When the fur trade declined, Fort Laramie was an important stopover for emigrants to California, Utah, and Oregon who were taking the Oregon Trail.

The government bought Fort Laramie in 1849, offering protection for Oregon Trail travelers as well as for those trekking to the California gold fields. In 1851 around 10,000 Native Americans came to the post and agreed to the Treaty of Fort Laramie, essentially giving westward-bound settlers a safe passageway in return

A formation is arrayed before officers' row at Fort Laramie in 1885.

for annuities. Significant events took place at Fort Laramie for decades, and eventually it contained 150 structures. But the end of the Indian Wars caused Fort Laramie to be abandoned in 1890. The state of Wyoming bought the old fort in 1937 and donated it to the federal government one year later. A variety of living history demonstrations serve to restore the vigor of old Fort Laramie.

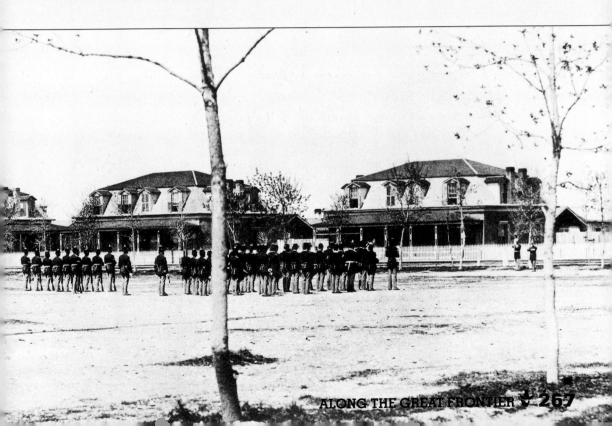

Fort Phil Kearny, Wyoming

Fort Phil Kearny was a model of the classic stockaded outpost. Most western "forts" were actually laid out as military towns around a large parade ground, but Fort Phil Kearny needed elaborate fortifications for its very existence.

The fort was built in 1866 to protect the Bozeman Trail, a shortcut to the Montana gold mines through Sioux territory. A log stockade was built that measured 1,600 feet in length, and 42 log buildings were erected inside the stockade. Sioux warriors constantly raided travelers, woodcutters, troop details, and livestock herds. Within a violent six-month period, they killed 154 Americans and stole 800 head of cattle during 51 hostile actions.

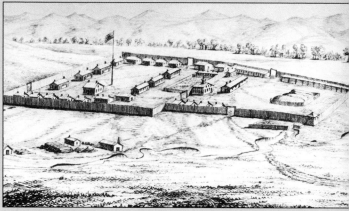

Fort Phil Kearny, erected to protect the troubled Bozeman Trail, needed the elaborate stockade to protect itself.

In 1868 the army gave up defending the Bozeman Trail and pulled out of Fort Phil Kearny. Before the soldiers were out of sight, warriors set the hated fort on fire. Today the building sites are marked, and the stockade has been partially reconstructed.

Fort Bowie, Arizona

Historic Fort Bowie was built in Apache Pass, where Second Lieutenant George Bascom tried to arrest Cochise in 1861. The **great chief escaped,** but his braves were captured and hanged, triggering **25 years of warfare** with the Apache. In 1862 Cochise and Mangas Coloradas battled the **California Column** in Apache Pass, and an outpost was built to control the pass and its springs.

Six years later, Fort Bowie was moved to a nearby plateau. Construction commenced on several substantial stone and adobe buildings; eventually there were three-dozen structures. During the pursuit of Geronimo, **General George Crook** established his headquarters at Fort Bowie. After Geronimo's surrender in 1886, the wily guerrilla leader was taken to Fort Bowie.

Fort Bowie was **abandoned in 1894.** Today it is possible to **drive** near the site then **hike** the final 1½ miles into rugged Apache Pass, where the **impressive ruins** stand ready to be explored.

Fort Abraham Lincoln, North Dakota

Fort Abraham Lincoln was the home of George Armstrong Custer and the ill-fated 7th Cavalry during the climactic years of the Sioux wars. Established in Dakota Territory in 1872, the fort was targeted by warriors even during its construction. There were three hostile actions directed against the post in 1873, and the horse herd was driven off by raiders the following year.

Custer and his wife entertained constantly. When their house burned in 1874, a larger "Custer House" was erected. When Custer led his regiment out of the post toward disaster in 1876, the officers' wives congregated at the Custer House. While singing hymns there, they were informed that their husbands had been killed.

When the Northern Pacific Railroad arrived in 1891, Fort Abraham Lincoln was abandoned. In a classic example of "midnight requisitioning," on the night of December 1, 1894, around 100 settlers descended upon the deserted fort, dismantled most of the buildings, and hauled away the materials with 60 draft teams.

George Armstrong Custer (far left) sits with officers of the 7th Cavalry and their wives on the porch of his house at Fort Abraham Lincoln. Most of these men would die at the Little Bighorn.

Fort Sill, Oklahoma

Fort Sill originated as a cavalry post to keep the peace on the Comanche and Kiowa reservations in southwestern Indian Territory. A great many Comanche and Kiowa—known in Texas as the Wild Tribes—were not reconciled to reservation life.

For example, one night warriors crept into the mule corral at the fort and shot at the two guards. When the guards fled, the braves stole the entire herd.

After this incident, the post commander, Colonel Benjamin Grierson, built a stone corral with high walls.

In another incident, General William T. Sherman ordered Colonel Grierson to arrest Comanche leader Satanta and others responsible for a wagon train massacre. Soldiers hid inside the commanding officers' residence and arrested the Comanches—who were at Fort Sill to receive their weekly provisions—after a deadly scuffle. Satanta is buried at Fort Sill, along with the great Comanche chief Quanah Parker and his mother, Cynthia Ann Parker. Apache leader Geronimo, who spent his last 15 years at Fort Sill, is also buried there.

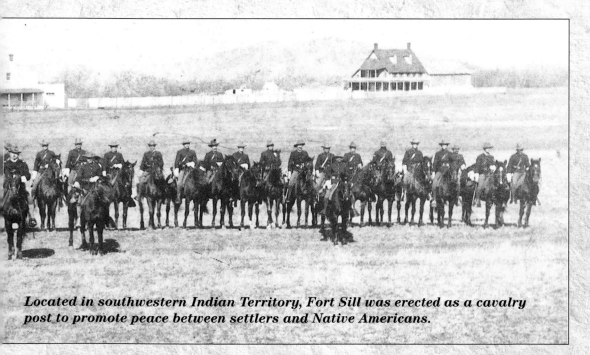

Located in southwestern Indian Territory, Fort Sill was erected as a cavalry post to promote peace between settlers and Native Americans.

"Dodge City is a wicked little town."

—reported by Washington, D.C.'s Evening Star

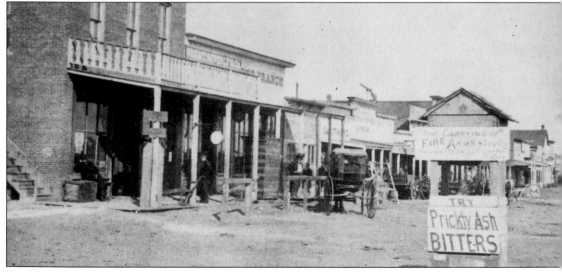

The two-story brick store on Front Street in Dodge City was Wright, Beverly & Co., next to the famous Long Branch Saloon. Note the sign prohibiting the carrying of firearms.

Dodge City, Kansas

Dodge City, the **"Bibulous Babylon of the Frontier,"** became the **most famous town** in the West. Dodge City began to develop a few miles west of Fort Dodge in 1872 when the Santa Fe Railroad reached the site. This railhead provided a **shipping point** for buffalo hides, with around 200,000 hides loaded onto railroad cars during the first winter.

Buffalo hunters **caroused wildly** through the ramshackle town, and gunfight victims were dumped into **Boot Hill.** More excitement began in 1876 when herds of Texas longhorns began to be driven to the railhead at Dodge. Roistering cowboys enjoyed the sinful pleasures of the **Long Branch Saloon, the Lady Gray, and the Comique Theatre.**

A western Who's Who strolled across Dodge City's Plaza. **Doc Holliday** and **Luke Short** gambled in Dodge, and Short shot an adversary in a gunfight. **Bat Masterson, Bill Tilghman,** along with **Wyatt** and **Morgan Earp** wore badges in Dodge. So did Bat's brothers, **Jim and Ed,** who were killed during a wild shoot-out with cowboys.

When 12 bulls were imported in 1884 for a widely publicized bullfight in Dodge, **Mayor A. B. Webster** was notified by a U.S. district attorney that such events were illegal in the United States. "Hell," retorted the mayor, **"Dodge City ain't in the United States."**

Cattle Drives

By the end of the Civil War, there were **five million** longhorn cattle roaming the open grasslands of south and west Texas. These wild beasts belonged to no one, and many Texans recognized the profit potential of delivering cattle to northern and eastern markets.

But the nearest railroads were far to the north, so for two decades cowboys drove herds of tough longhorns to **raucous** Kansas railheads. The Chisholm Trail, blazed by Jesse Chisholm, led to Abilene and—as rails were extended southward—to Newton, Wichita, and finally, Caldwell. A parallel route, the Western Trail, went to Dodge City, the most famous of the cow towns. The Goodnight-Loving Trail, founded by legendary cattle rustler Charles Goodnight and his partner, Oliver Loving, followed the Pecos River out of West Texas and north through New Mexico to the gold fields of Colorado.

On the trail, drovers contended with stampedes, storms, dangerous river crossings, and many other difficulties. At the end of three months or longer, cowboys were paid $100 to $150, which sometimes was spent during three or four days of **riotous celebration.**

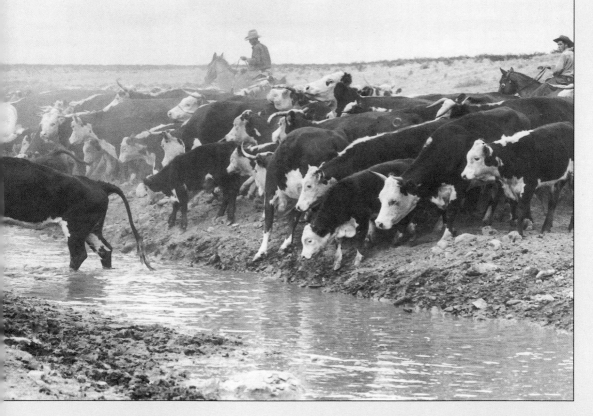

No western activity captivated the American imagination more completely than cattle drives. The era of the famous "long drives" lasted from the end of the Civil War until the mid–1880s.

Best Cattle Drive and Cowboy Movies

Red River (1948) John Wayne

The Tall Men (1955) Clark Gable

◀ *Giant* (1956) James Dean, Elizabeth Taylor

The Big Country (1958) Gregory Peck

Cowboy (1958) Glenn Ford, Jack Lemmon

Will Penny (1968) Charlton Heston

Monte Walsh (1970) Lee Marvin

The Cowboys (1972) John Wayne ▶

The Culpepper Cattle Company (1972) Gary Grimes

Comes a Horseman (1978) Jane Fonda, James Caan

Chuck Wagons

While preparing for a long trail drive in 1866, pioneer cattle rustler Charles Goodnight bought a surplus army wagon and had it **rebuilt** to accommodate the needs of a crew of drovers. A **big toolbox** was attached to one side of the wagon, while the other side accommodated a **water barrel.** At the rear was a **"chuck box"** of Goodnight's design, filled with **drawers** and **shelves** and covered with a hinged lid that dropped down on a swinging leg to form a cook's worktable.

The drawers and shelves were packed with whiskey, castor oil, bandages, vinegar, tobacco, matches, plates, cups, cutlery, sugar, dried fruit, pinto beans, coffee, a coffeepot, salt, lard, baking soda, molasses, and sourdough. The **boot,** or lower part of the chuck box, contained skillets and Dutch ovens. Along with flour sacks and other provisions, the **wagon bed** hauled the crew's bedrolls, slickers, an extra wagon wheel, guns and ammunition, and a lantern and kerosene supply.

Goodnight's **efficient design** was copied by range outfits all over the West, and eventually the **Studebaker** company and other wagon makers manufactured chuck wagons to this **popular** pattern.

A range crew is shown gathering around a chuck wagon on the Matador Ranch in Texas. Pioneer cattle rustler Charles Goodnight devised a supply wagon equipped with a chuck box with a hinged lid for the cook's worktable. Bachelor ranchers sometimes nailed a chuck box to the kitchen wall for their pantry and table.

ABILENE, KANSAS

Cattle buyer Joseph G. McCoy intended to develop a town along the new Kansas Pacific Railroad that would attract trail drivers from Texas. In 1867 he found Abilene, "a small, dead place, consisting of about one dozen huts," surrounded by grassy plains and watered by Mud Creek and nearby Smoky Hill River.

"At this writing, Hell is in session in Abilene."

—*printed in the* Topeka Commonwealth

Buying 250 acres adjacent to this hamlet, McCoy erected shipping pens, barns, livery stables, a bank, and the Drover's Cottage, which was a three-story hotel. He sent riders to Texas to direct herds up the Chisholm Trail toward Abilene, and by 1870 McCoy's facilities were handling 160,000 cattle in a single season.

The rambunctious young drovers, with money in their pockets, swaggered along Texas Street, enjoying themselves in the Alamo Saloon, the Bull's Head Saloon, the Lone Star Saloon, and the Novelty Theatre. Abilene was the first Wild West town where Texas cowboys engaged in mass drinking and brawling sprees, thereby establishing an indelible image throughout the nation.

> **"Gathered together in Abilene and its environs is the greatest collection of rascals, desperados and adventuresses the United States had ever known."**
>
> —*printed in the* New York Tribune

> **"It was a wide-open settlement with no civic organization, no jail, no court, practically no attempt at police control. Everybody was free to be drunk everywhere, to gamble in public, to shoot, to kill."**
>
> —*A wide-eyed visitor*

Deadwood, South Dakota

For decades rumors circulated that there was **gold** in the Black Hills. In November 1875 a party of prospectors found gold on **Whitewood Creek**, and within weeks a tent city went up along Deadwood Gulch. During 1876 more than 20,000 people swarmed into the area, and frame saloons, dance halls, and stores were erected on the floor of the narrow gulch.

The muddy main street was filled with people and horses, mule- and ox-drawn wagons, and huge piles of lumber for construction projects. Prospectors panned for gold and ran sluice-boxes, a way to filter water like a floodgate, along Deadwood Creek and other nearby streams.

Wild Bill Hickok was the most famous of the frontier notables who gravitated to the West's newest boomtown, but he was soon murdered. Texas cowboy **Sam Bass** went broke on a mining venture then assembled a gang and robbed seven stagecoaches in the area.

Wild and woolly Deadwood was scourged by a devastating fire in 1879 and by a raging flood just four years later. But the enormous **Homestake Mine** and other mines continued rich production, and Deadwood was rebuilt again and again.

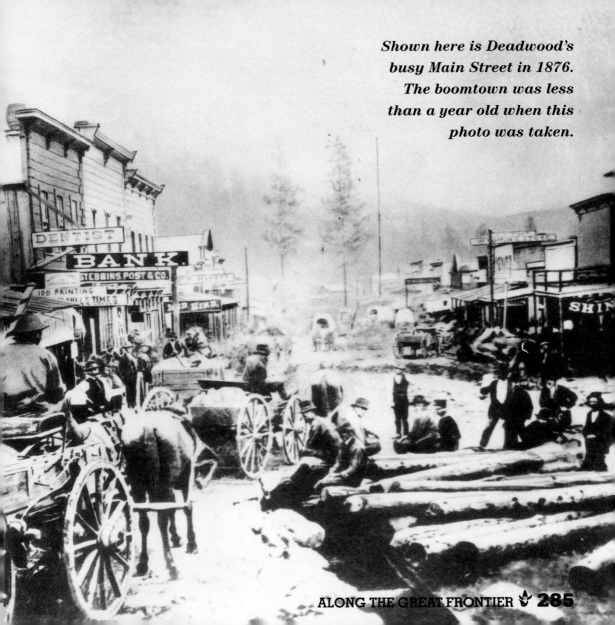

Shown here is Deadwood's busy Main Street in 1876. The boomtown was less than a year old when this photo was taken.

Aces and Eights

Wild Bill Hickok was known as the **"Prince of the Pistoleers"** when he arrived in Deadwood in the spring of 1876. The 39-year-old adventurer recently had married in Cheyenne, but he left his bride to seek excitement in the West's latest boomtown.

Hickok wrote to his wife that he was hard at work as a prospector, but she didn't know that all of his gold-seeking was done at a poker table in Deadwood's **Saloon No. 10.** During the afternoon of August 2, Hickok entered a game with three friends. A little after four o'clock, Wild Bill was dealt a queen, a pair of aces, and a pair of eights—a combination about to become famous as the **"Dead Man's Hand."**

A young drifter named Jack McCall suddenly walked up behind Hickok and triggered a .45-caliber slug into the back of his head, killing him instantly. McCall was tried and sentenced to hang. He was asked, "Why didn't you go in front of Wild Bill and shoot him like a man?"

McCall candidly replied, "I didn't want to commit suicide."

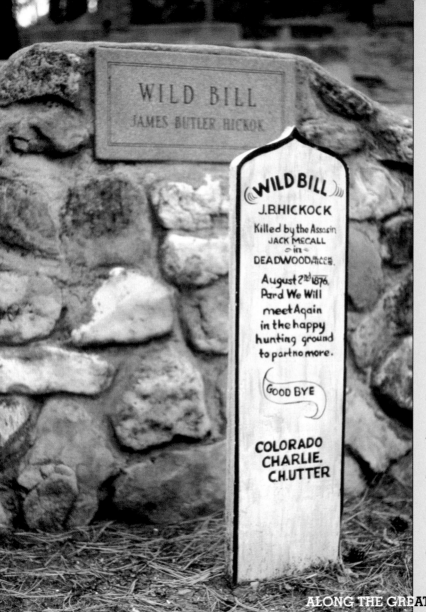

Deadwood's Mount Moriah Cemetery contains the grave sites of two famous Westerners, Wild Bill Hickok and Calamity Jane. She arranged to be buried next to the Prince of Pistoleers, suggesting a closeness between them that had not existed in real life.

Tombstone, Arizona

When prospector **Ed Schieffelin** prepared to explore the Apache-dominated San Pedro Valley, soldiers told him he would find only his tombstone. After discovering a fabulously wealthy silver vein, Schieffelin cheerfully named it the Tombstone.

"Every tombstone needs its epitaph."
—*John Clum, explaining how his newspaper,*
The Tombstone Epitaph, *got its name*

Other miners swarmed to the area seeking their own fortunes, and in 1877 the first permanent dwelling was erected in Tombstone. Eastern capital poured in to develop the mines, and the population soared to 15,000. Even though fires blazed through the boomtown's business district in 1881 and 1882, Tombstone was rapidly rebuilt after each disaster.

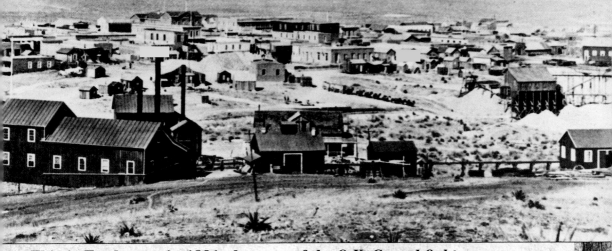

This is Tombstone in 1881, the year of the O.K. Corral fight.

At least 110 establishments were built to dispense liquor, including the popular Crystal Palace and Oriental saloons. Rowdy entertainment was available around the clock at the **Bird Cage Theatre**. The Bird Cage served up whiskey, women, gambling, and stage acts 24 hours a day for eight years. The walls and ceilings today sport **140 bullet holes,** the result of exuberant patrons and at least **16 gunfights.**

Tombstone's first city marshal was shot dead, and there were numerous other shoot-outs. The violence ended when the mines closed and the population dropped. But when twentieth-century tourists discovered Tombstone, **"the town too tough to die"** reawakened and lived up to its name.

Tombstone was an ideal name for a town that was the site of the West's most famous gunfight, as well as a string of other deadly shoot-outs. Doc Holliday walked the dusty streets of Tombstone, as did Johnny Ringo, Luke Short, Buckskin Frank Leslie, Bat Masterson, the Earp brothers, the Clantons, and the McLaurys. Some of these men found permanent residence in Boot Hill, while others dispatched victims to Tombstone's celebrated "bone orchard."

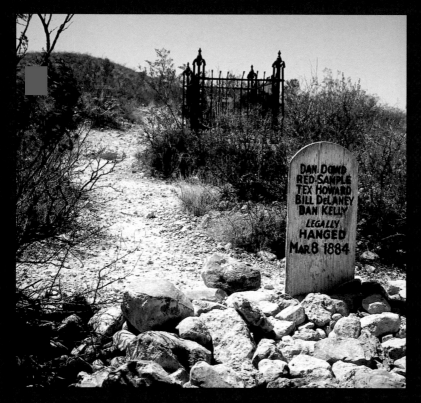

Boot Hill

As the mining town of **Tombstone** grew, Boot Hill received the first of more than 250 permanent inhabitants in 1878. The most famous of these quiet residents are **Frank** and **Tom McLaury** and **Billy Clanton,** all killed at the O.K. Corral. Billy the Kid Claiborne and Charlie Storms, shot at the Oriental Saloon by Buckskin Frank Leslie and Luke Short, respectively, were deposited at Boot Hill. So was the town's first marshal Fred White, killed by Curly Bill Brocius.

Florentino Cruz, slain by Wyatt Earp and his party during the bloody aftermath of the O.K. Corral, was interred here. Arizona officer of the law Jeff Milton, who resided in Tombstone, provided Boot Hill with a latecomer, Three-Fingered Jack Dunlap, killed while trying to rob a train in 1900.

Many other **gunfight losers** lie beneath Boot Hill, along with a number of murder victims and several people who were legally hanged. There were prostitutes, many of whom committed suicide, and there was a Chinese section. While the original wooden markers are gone, new markers have been placed, although many grave sites remain **unknown.**

Best Tombstone, Earp, and Doc Holliday Movies

Law and Order (1932) Walter Huston

Frontier Marshal (1939) Randolph Scott

Tombstone: The Town Too Tough to Die (1942)
Richard Dix

My Darling Clementine (1946) Henry Fonda

Wichita (1955) Joel McCrea

Gunfight at the O.K. Corral (1957) Burt Lancaster

Warlock (1959) Henry Fonda

Hour of the Gun (1967) James Garner

Tombstone (1993) Kurt Russell

Wyatt Earp (1994) Kevin Costner

Henry Fonda in My Darling Clementine.

The actor who played the Wyatt Earp character is listed after the title and date. But loyal, doomed Doc Holliday offers a more complex and colorful characterization, attracting such actors as **Cesar Romero** (*Frontier Marshal*), **Kent Taylor** (*Tombstone: The Town Too Tough to Die*), **Walter Huston** (*The Outlaw*, 1943), **Victor Mature** (*My Darling Clementine*), **Kirk Douglas** (*Gunfight at the O.K. Corral*), **Arthur Kennedy** (*Cheyenne Autumn*, 1964), **Jason Robards** (*Hour of the Gun*), and **Stacy Keach** (*Doc*, 1971). In *Tombstone*, **Val Kilmer** stole the movie with his drunken, humorous performance. And for *Wyatt Earp*, **Dennis Quaid** lost 42 pounds and brought Doc back to life.

Kirk Douglas (left) and Burt Lancaster in Gunfight at the O.K. Corral.

THE FIVE BEST-DRESSED WESTERNERS

Shootist: Wild Bill Hickok. For riding he donned beaded and fringed buck-skin suits, moccasins or high boots, double-breasted shirts, and flat-brimmed hats. But whenever possible Hickok dressed up in checkered pants, a cape with a plaid lining, an assortment of fancy waistcoats and neckties, jeweled collar studs, a coat with satin facings, and a sash where he tucked a brace of revolvers, butts forward.

Outlaw: The Sundance Kid. Following a successful robbery, Butch Cassidy and the Wild Bunch enjoyed vacationing in such cities as Fort Worth, San Antonio, and Denver, where he bought fashionable clothes for roistering in saloons and bordellos. Cassidy, Harry Longbaugh (The Sundance Kid), and three other gang members showed off their snappy attire in a group photo taken in Fort Worth. All five outlaws were wearing derbies and three-piece suits with watch chains.

Gambler: Luke Short. A picky dresser, the deadly gambler-gunfighter draped his

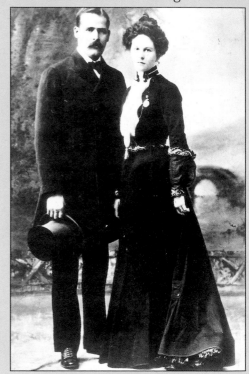

In a 1901 photo, with sweetheart Etta Place in New York City, Harry Longbaugh wore a silk top hat, dark double-breasted suit, bow tie, and polished shoes.

small frame (five-foot six-inches, 125 pounds) in tailored clothes. Short arrayed himself with a silk hat, double-breasted suit and matching overcoat, silver-headed cane, kid gloves, and diamond stickpin. Feeling that a gun belt and holster were unseemly with his suits, he had his right pants pocket cut extra long and lined with leather to hold his revolver.

Law Officer: Bat Masterson. By the time Masterson was elected sheriff of Ford County, Kansas, in 1877, he had doffed the rough clothing of a buffalo hunter for more stylish garb. He habitually wore a bowler, as well as a fashionable coat, vest, and tie, and a heavy watch chain. Masterson carried a walking stick, partially because of a pelvic wound suffered in an 1876 gunfight, and in Dodge City the dapper sheriff used his cane to knock drunken troublemakers senseless.

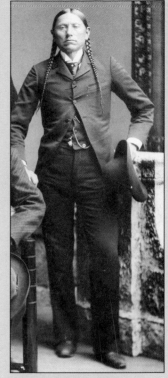

Quanah Parker

American Indian Chief: Quanah Parker. As a young man Quanah Parker was a Comanche warrior, and after being confined to the reservation he became head chief of the tribe. Half white and half Comanche, Parker shrewdly arranged lease agreements with Texas ranchers and deftly negotiated with federal officials on behalf of his people. Parker was a popular celebrity at parades and various other occasions, and he made numerous visits to Washington. Considered a strikingly handsome man, Parker wore three-piece suits, jeweled tie pins, watch chains and fobs, and derby hats, while carrying a slender walking stick.

This is a view of Lincoln in the 1880s.

Lincoln, New Mexico

Mexican-American settlers in the 1850s established a community they named *La Placita del Rio Bonita* ("The Little Town by the Pretty River"). They erected a stone *torreon*, or tower, as a refuge from attack by Apache raiders, and additional protection was available from Fort Stanton, established 10 miles to the west in 1855.

As the town developed, flat-roofed adobes were built on either side of the only street, which wound parallel to the Rio Bonita about one mile, east to west. *La Placita* was renamed Lincoln in 1869 when it was made the seat of the largest county in the United States. Comprising the entire southeastern quarter of New Mexico, Lincoln County covered 27,000 square miles. But this vast province was inadequately policed by a sheriff and a handful of deputies, making frontier outlawry and violence inevitable.

From a peak of 500, the population sank to 50 after the county seat was moved in 1913. But modern visitors can still enjoy two fine museums and one of the West's least changed historic towns.

The Lincoln County War

Lincoln was the focal point of a power struggle between two factions over ranching, banking, and mercantile enterprises. The **conflict** came to a flash point on February 18, 1878, when Sheriff William Brady and a large posse **murdered** rancher John Tunstall in the countryside. Sheriff Brady and Tunstall were among the leaders of their respective factions, and the brutal killing of the popular rancher triggered an **all-out war.**

A band of "Regulators," which included a Tunstall employee called Billy the Kid, rode in revenge. For several months Lincoln County was wracked by murders, ambushes, and running fights from horseback. The most **spectacular** incident was the **killing** of Sheriff Brady and a deputy on Lincoln's principal street by Billy the Kid and other Regulators.

The Lincoln County War came to a head during the bloody **five-day Battle of Lincoln.** The Kid and nearly 50 Regulators shot it out in

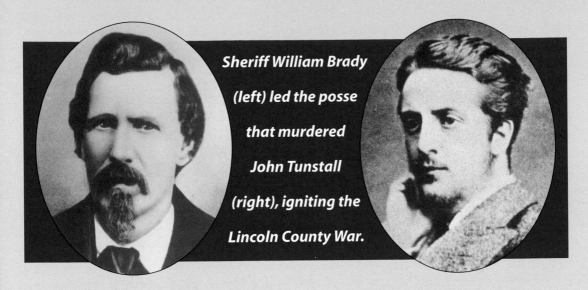

Sheriff William Brady (left) led the posse that murdered John Tunstall (right), igniting the Lincoln County War.

town with an even larger force. When a large cavalry detail arrived with a howitzer and Gatling gun, most of the Regulators slipped out of town. On the night of July 19, 1878, the Kid and the remaining Regulators tried to shoot their way out of a burning house.

The Kid escaped, and although the power of the Regulators was broken, Billy formed a **gang** of horse thieves. New Sheriff Pat Garrett launched a relentless hunt, resulting in more shoot-outs, a murderous jail escape, and **finally** the death of the Kid.

Bodie, California

In 1859 prospector Bill Bodey and three partners found gold on the eastern slope of California's Sierra Nevada. Bodey **froze to death** in a blizzard his first winter in camp, but today one of the West's premier ghost towns bears an **altered spelling** of his name.

For a decade and a half, the town of Bodie remained a small mining camp with only a couple dozen cabins. But in 1876 a cave-in at Bunker Hill Mine revealed a rich vein, and within a year, there were 2,000 people living in Bodie. Another discovery, in 1878, produced ore that assayed at $1,000 per ton, pushing the population past 10,000.

Bodie's **main street** extended for a mile. There were 65 saloons, and the red-light district centered on Virgin Alley and Maiden Lane. There were so many gunfights and robberies that the *Sacramento Union* maintained a **reporter** in Bodie to keep its readers **entertained** with the most recent crimes.

This is a view of Bodie from the Standard Mine. Despite fires and more than a century of severe winter weather, at least 150 structures still survive.

The inevitable production decline began in the 1880s, and Bodie was deserted by the 1930s. Fires in 1892 and 1932 damaged the old town, as did the harsh winter weather. However, a 13-mile jaunt on an old gravel road will bring an adventurous traveler to a jewel of a ghost town, with more than 150 buildings intact.

Five Best Gunfight Sites

Tombstone, Arizona. This is the location of the West's most famous shoot-out, as well as killings by Luke Short, Buckskin Frank Leslie, and other noted gunfighters. Both Virgil and Morgan Earp were bushwhacked here. Today it's a major western tourist attraction.

Billy the Kid was jailed in the front upstairs corner room at left of the old Lincoln County Courthouse in 1881, but he killed two guards and escaped. Bullet holes are still in the wall.

Lincoln, New Mexico. Structurally, little has changed from the 1870s and its years as the battleground of the Lincoln County War. Lincoln today would look familiar to Billy the Kid.

Rock Creek Station, Nebraska. The complex of buildings has recently been rebuilt where Wild Bill Hickok shot Dave McCanles and two friends in the 1861 gunfight that made Wild Bill famous.

Blevins House, Holbrook, Arizona. Today you can walk onto the same front porch where, in 1887, Sheriff Commodore Perry Owens shot down four adversaries while trying to make an arrest.

#11 Saloon, Pecos, Texas. Bullet holes still remain in walls of the saloon where rancher-gunfighter Barney Riggs killed two attackers in 1896. Gunfighter Clay Allison is buried behind the building.

Silver City, Idaho

In 1863 a band of prospectors went in search of the **Blue Bucket Diggings,** a legendary gold field rumored to exist in the Owyhee Mountains of southwestern Idaho. The expedition found pay dirt along a stream at 6,000 feet, triggering a stampede of prospectors.

During the next two years, more than 250 mines were opened. The fabulously rich Poorman Mine was discovered by miners too poor to develop it, while another mine, the War Eagle, produced $30 million worth of ore within a decade. Silver City enjoyed years of prosperity as one of the great **bonanza** sites of the West. A population of 5,000 enjoyed theaters, saloons, hotels, lodge halls, churches, and a handsome school.

The financial depression of the 1870s initiated a sudden population drop to less than 600. Mining capitalist Joseph DeLamar purchased and devel-

oped a number of mines in the district. Despite such efforts, permanent decline had hit. After being awarded the seat of Owyhee County in 1867, it was transferred away to Murphy in 1935, and within a few years, **"Old Silver"** became a ghost town.

Pony Express

During the 1850s, the fastest mail delivery to California was along the Butterfield stagecoach route. Business messages could be telegraphed from the East Coast to Missouri, then placed on stagecoaches. One-way deliveries took 21 days, and return messages required another 21 days. Perhaps the pace was tolerable for personal correspondence, but business mail needed speedier delivery.

The enterprising freight firm of Russell, Majors & Waddell devised a system of relay riders who could provide delivery in just 10 days. This pony express stretched from St. Joseph, Missouri, to Sacramento, California. Relay stations were placed every 10 to 15 miles; there were 190 stations along the 1,840-mile route. Most of the 400 horses were mustangs, while most of the 80 riders were slender teenagers. Other employees included station keepers, stock tenders, route superintendents, and teamsters who shuttled supply wagons to the stations.

The pony express operated for only a year and a half until the first coast-to-coast telegraph was completed.

Isolated station employees and solitary riders faced mortal danger from war parties that desired the company's horses.

Each rider was assigned a 75-mile route, which he would ride back and forth, east and west. Saddles were lightweight, and the mail was carried in a leather *mochila* (Spanish for "knapsack") slung over the saddle. There were four locked pockets, two on each side of the mochila, which could carry about 250 letters written on tissue paper. The cost was $5 per ounce.

On April 3, 1860, crowds in St. Joseph and Sacramento cheered as pony express riders galloped toward each other from separate ends of the frontier. The youthful "pony riders" became national heroes as they galloped alone through hostile country.

The pony express came to an abrupt end after only a year and a half of operation. When the first coast-to-coast telegraph was completed, a suddenly obsolete pony express delivered its last mochila on October 24, 1861. The unprofitable enterprise had cost Russell, Majors & Waddell between $100,000 and $200,000, but it left a colorful legacy of bravery and adventure.

"Our coach was a great swinging and swaying stage, of the most sumptuous description—an imposing cradle on wheels. It was drawn by six handsome horses. . . . We changed horses every ten miles, all day long, and fairly flew over the hard, level road."

—*Mark Twain,* Roughing It

Stagecoaches

First manufactured in 1826 by the **Abbot-Downing Company** of Concord, New Hampshire, the Concord stage evolved into the first passenger vehicle in the West. The Concord stood **eight feet high** and weighed **2,500 pounds.** There were three upholstered benches inside: one in back, one in front, and one in between.

Three passengers could sit on each bench, and another two could ride on top. The driver and a shotgun messenger sat in front, while baggage and mail were stowed in a rear boot or strapped on top. Other stagecoaches used steel braces, which delivered a jolting ride, but the Concord featured **thick leather thoroughbraces** that served as shock absorbers. There were leather curtains at the windows, and decorative painting added to its appearances. Concords sold for $1,050 to $1,500.

Even after railroads penetrated the West, stagecoach lines continued to serve isolated communities into the 1890s. And Wild West shows and motion picture companies would continue to maintain sturdy old Concords for **crowd-pleasing scenes.**

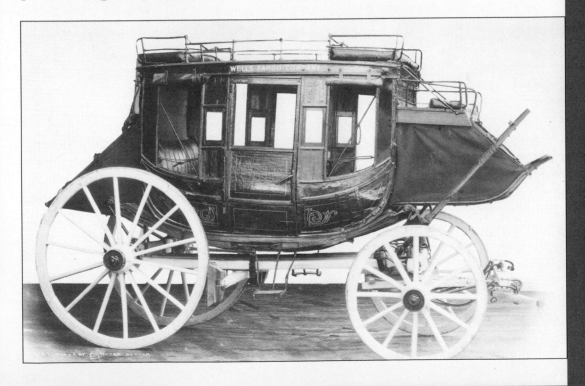

Soddies and Dugouts

When the westward movement reached the treeless Great Plains, pioneers could no longer build log cabins as free housing. But with the characteristic adaptability of the American frontiersperson, they soon began to dot the plains with houses constructed of sod "bricks."

Large sod squares were dug out of the ground and stacked up **two-deep** to form walls about three feet thick. A typical soddy required about **half an acre** of land to be stripped for blocks. Cottonwood poles from the

nearest stream bed—which might be a good distance away—formed a **base** for the sod roof. Since the dirt roof soon would dry up and blow away, grassy squares were taken from the ground to form a **grass roof** for the soddy. In case of attack by a war party, settlers could fort up without worrying about their cabin being burned.

If the room or rooms were dug two or three feet into the ground, the walls would only have to be built three or four feet high. Such a dugout would be cooler in the summer and warmer during the winter. If there was a convenient rise on the homesteader's property, the sod house might be built **into** the hill, which provided the back wall and part of the sides. Since there was grass on the roof, however, **grazing cattle** might wander over and **crash** down into the house, making it wise to **fence** off the roof.

Inside, the **earthen floor** was swept to hardpan, and the owners might take a stick and trace flowers or other decorative designs into the floor if company was expected. Walls sometimes were lined with newspapers, but it was impossible for even the most fastidious housekeeper to keep the table and other furniture free of dust. When heavy rains soaked the roof, **mud dripped inside** for about three or four days. The sod materials offered no obstacle to mice, snakes, and all manner of insects, so pioneer families simply resigned themselves to **sharing** their innovative dwellings with some of the **natural inhabitants** of the area.

Grafton, Utah

Colonized by Mormon farmers in 1859, Grafton was home to nearly 30 families (168 people) by 1864. These industrious colonists cultivated cotton, planted orchards, and dug more than seven miles of canals and ditches to work 200 productive acres.

Because of the constant danger of American Indian attacks, many worked the fields with loaded guns nearby. The Grafton cemetery became

Built in 1886 with donated labor, Grafton's adobe school doubled as a Mormon meeting house.

the final resting place for many who died from arrow wounds.

Grafton boasted a church, school, post office, and a variety of log, frame, and adobe residences. But severe flooding caused a population decline. In 1921 with only three families remaining, Grafton ceased to be part of the Mormon Church and soon was deserted.

But three decades later Hollywood discovered the rustic ghost

Actors Paul Newman and Katharine Ross starred in the Grafton film Butch Cassidy and the Sundance Kid, *one of many Westerns lensed in the photogenic ghost town.*

town set against a spectacular mountain. Grafton lives on in several western movies, including the 1969 blockbuster, *Butch Cassidy and the Sundance Kid.*

VOICES OF THE GREAT WEST

"Sometimes we have the seasons in their regular order, and then again we have winter all the summer and summer all winter [in Nevada]. . . . It is mighty regular about not raining, though. . . . But as a general thing . . . the climate is good, what there is of it."

—*Mark Twain*

INDEX

Picture credits:

Front and back covers: **PIL Collection**

AP Wide World Photos: 170, 180, 183, 235; **Art Resource:** 130; National Portrait Gallery, Smithsonian Institution, 217, 239, 243; Scala, 190; Smithsonian American Art Museum, Washington, D.C., 152, 238, 240–241; Victoria & Albert Museum, London, 260; **Brown Brothers:** 8, 13, 38, 39, 58, 125, 192, 193, 236, 244, 294; **Dietrich Leis Stock Photography:** Dick Dietrich, 290; **Collection of Ellwood House Museum, DeKalb, Illinois:** 222, 223; **Getty Images:** 50, 133; **Janet Hamlin:** 52, 117; **Houserstock:** Dave G. Houser, 97; ©2006 **Kerrick James:** 191; **Jeremy Parker Photography:** 312; **Laurence Parent Photography:** 302; **Library of Congress:** 71, 295; **PhotoDisc Collection:** 144, 314–315; **PIL Collection:** 4, 7, 11, 15, 16, 19, 22, 25, 27, 32, 33, 35, 36, 40, 41, 42, 43, 44, 47, 49, 55, 56, 59, 60, 65, 66, 69, 70, 73, 75, 81, 82, 85, 87, 93, 94, 96, 99, 102, 104, 106, 108, 111, 115, 119, 121, 122, 123, 128, 131, 135, 136, 139, 141, 142, 143, 145, 147, 149, 155, 157, 158, 161, 163, 164, 167, 168, 169, 172, 173, 174, 178, 179, 184, 185, 187, 188, 196, 201, 203, 205, 206, 211, 215, 218, 219, 228, 231, 248, 251, 252, 257, 261, 263, 264, 267, 268, 271, 272–273, 274, 277, 278, 281, 283, 285, 289, 293 (top), 296–297, 299, 301, 305, 306, 309, 310, 313; Paramount Pictures, 229, 293 (bottom); RKO Radio Pictures, Inc., 208; United Artists, 129; Warner Bros., Inc., 10, 209, 279; **SuperStock:** 5, 28, 78, 80, 150–151, 153, 195, 199, 221, 255, 258–259, 287; David David Gallery, 194; Newberry Library, 227; David Spindel, 127; **Transcendental Graphics:** 177; **Courtesy of True West Magazine:** 21, 253; **Courtesy of UTA Magazine, University of Texas at Arlington:** 57; **Ed Vebell Collection:** 9, 14, 17 (top), 18, 23, 30, 31, 62, 63, 76, 77, 90, 91, 100, 101, 175, 212, 213, 225; Steve Crowley, 17 (bottom); Jonathan Peck, 24, 37; Jonathan Peck/Ed Vebell, 89; Don Spaulding, 233.

Color tinting by Cheryl Winser.